D0461404

WITHDRAWN BECAUSE:

_____ Bad Condition

_____ Out-of-Date

____✔____ Low Demand

Fairfax
County
Public
Library

# The WINTER CHILD

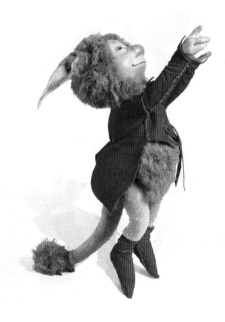

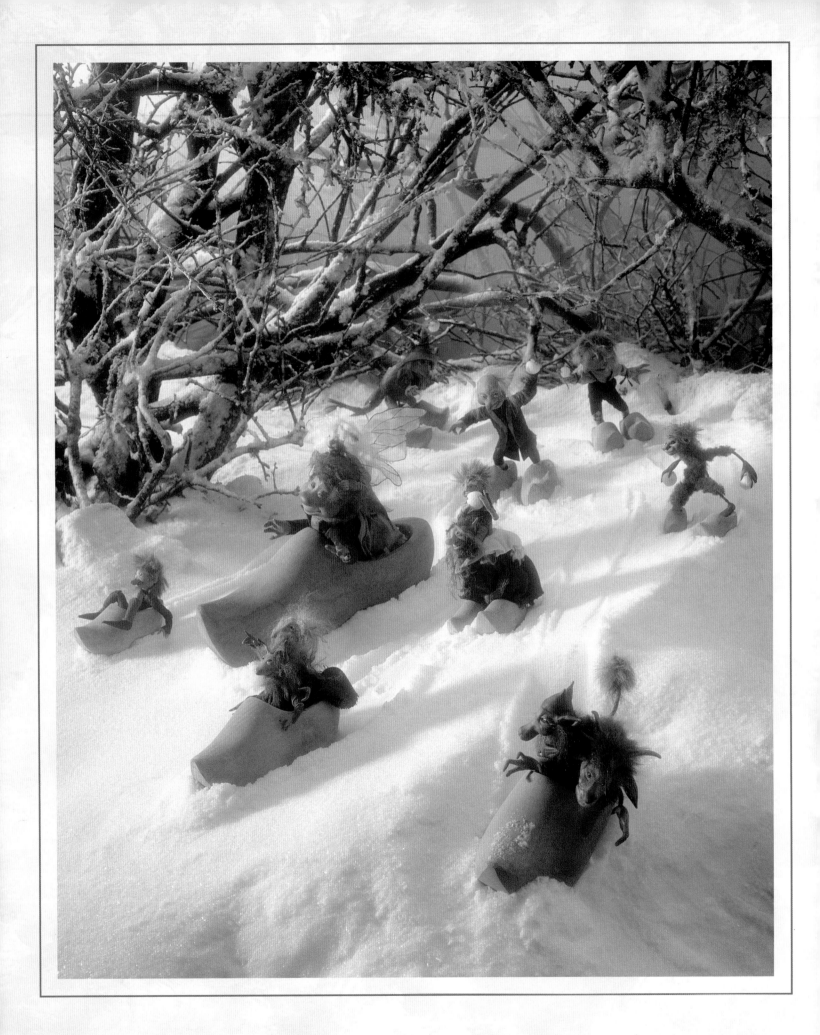

# The Winter Child

*Art by* WENDY FROUD

*Story by* TERRI WINDLING

*Photographs by* JOHN LAWRENCE JONES

*Sets and Photographic Art Direction by* BRIAN FROUD

SIMON & SCHUSTER

NEW YORK    LONDON    TORONTO    SYDNEY    SINGAPORE

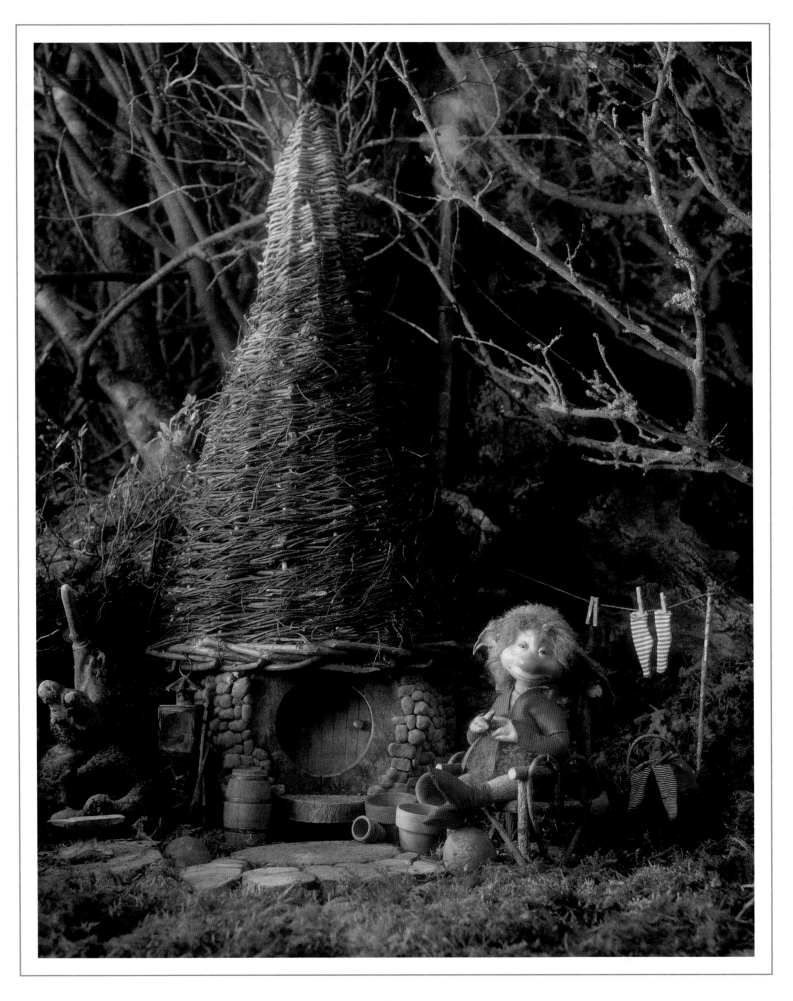

The faery court of Old Oak Wood was not the largest in the British Isles, but it was the oldest, steeped in elfin history and tradition. Ruled by Titania and Oberon, those celebrated lovers of story and song, the wood was a misty, mossy place hidden deep in the hills of Dartmoor. The court maidens of Old Oak Wood were said to be the most beautiful, its dancers lightest on their feet, its flying faeries faster than the wind. Its wizards and its warriors were famed throughout the faery realm. But young Sneezle was none of these things; he was just a humble tree root faery who lived in a small round house at the very bottom of Greenmoss Glen.

*    *    *

On Midwinter's Eve, Sneezle dressed up in a red tailcoat and red felt boots, for this was the winter holiday celebrated throughout the realm. Tonight, on the longest night of the year, the king of the forest would lead the revels, just as the queen presided over the Midsummer's Eve procession. Sneezle tended to fall asleep just before these midnight celebrations, but not tonight. He combed his ears and tail, and then he was ready.

The young faery left Greenmoss Glen on a path that wound through silver birch, their slim trunks gleaming white against the blue shadows of twilight. The trail led east, to Golden Springs and the lovely Winterglade beyond—a sacred place, used only at this special time of year. At dusk the path was crowded with piskies, brownies, blue-caps, hobs, and bobs. Green maidens flew over their heads on wings formed of color and light. Behind them came the elfin knights, their silver hair long and unbound, mounted on red deer with ribbons tied onto their horns. Nixies joined them at the springs, rising from golden, iron-rich water; their long wet hair and skirts left trails of puddles on the eastern road.

The Winterglade lay just ahead. Sneezle could hear the court already: laughter and soft music played on harps of alder wood. The path snaked down a rocky slope and into a broad clearing below, circled by oak and rowan festooned with silks in red and gold. The Royal Committee for Forest Decoration had done a splendid job this year—and yet, Sneezle thought as he entered the circle, the glade didn't look quite right. The grass should be carpeted by snow, the rowan trees should have lost their berries . . . but autumn lingered in Old Oak Wood like a party guest who refused to go home. The trees were still laden with autumn's fruit; the leaves had turned but not fallen. The air was warm, *too* warm, and winter had not yet made an appearance.

Already the glade was crowded with faeries of every type, description, and size—from tiny sylphs in cobweb lace to tall lordlings in velvet and jewels. Serving gnomes moved through the court with trays of candied mistletoe and goblets of the pale oak wine traditional at Midwinter. Flying maidens peeked down from the trees, giggling behind their hands, while fiddlers tuned their instruments, jugglers juggled, tumblers tumbled, and fireflies drew rounds of applause weaving patterns of light overhead.

Sneezle pushed his way through the jostling throng till he reached the High Table, where the king and queen sat close together, looking down over the revels. His good friend Twig, a marsh thistle faery, was somewhere among the queen's attendants. He scrambled under the tablecloth and crawled past velvet slippers and shoes, searching for Twig's bare feet among them—probably muddy as usual.

Inching forward, Sneezle recognized the faery king's voice overhead. Oberon did not sound happy, and Sneezle cocked an ear to listen. "It's just not right," the king was saying. "Something's amiss— don't you feel it, too? We've always had snow on Midwinter Eve, not green grass and ripe blackberries! It should be *cold* this time of year. I'm sweating in this blasted velvet."

"Perhaps the Big People are meddling with the weather," said the faery queen with scorn. All

faeries have been affected, time after time, by the things we humans do to the world—which is why so many faeries now hide themselves away from us. "But even so, these rites of ours have always helped the seasons to turn. When we welcome winter with this feast, surely the snows will come."

"Indeed, you may be right," said Oberon, "and yet, my dear, I'm troubled. I mean to consult the Council of Sorcerers tomorrow, by raven post. I want to know precisely what has caused this winter's long delay. I'll write to old Master Malagan. I assume he's still head of the Council . . . ?"

"I suppose he is," the queen answered, "but it's been more than a hundred years since I've laid eyes on those fusty old souls . . . not since the Goblin Wars ended. Now, no more talk of weather and wizards. The dancing is about to start, and everything must be perfect tonight to call winter back to the forest."

The musicians struck up a lively air as Sneezle emerged on the table's other side, half hidden by the fluttering skirts of the tall court ladies surrounding him. Closest to Titania's throne were the queen's lovely royal handmaidens. Three of them were the elegant faeries he'd saved from enchantment the summer before; and behind them, younger and smaller, was the fourth handmaiden, Twig. Sneezle sighed. Just an hour ago, Twig's skirt had been clean, her wings washed and pressed, her hair pinned up in a delicate crown—but sitting still and keeping clean were never things she'd been good at. Now she stood with the other three handmaidens—a barnyard duck among swans, hanging back to hide her moss-stained skirt from the faery queen.

She brightened when Sneezle caught her eye and called to him to wait where he was. The king was about to give a toast and lead the queen in a Midwinter dance; then all the handmaidens would be freed from their duties and Twig could join him. As Sneezle waited, he spied a golden dish piled high with honey cakes—his favorite treat in all the world. The little faery licked his lips.

He sidled to the table's edge and cast a look at the courtiers. No one was watching him; all eyes were fixed on the royal couple.

Oberon stood, raising a cup of faery gold and amethyst.

"I drink to the moon and stars," he intoned the ancient words of the Midwinter rite. "I drink to the bitter cold, the ice, the snow, and the pale winter sun. On this, the darkest night of the year, we celebrate the great wheel of the seasons: birth, growth, decay, death, and renewal. Let us drink to renewal!"

The gathered faeries raised their cups, shouting, "To renewal! And to our king!" At that very moment Sneezle reached for a cake . . . and then he had it. He stuffed the whole cake in his mouth at once, filling his furry cheeks, and then looked quickly around the crowd to see if anyone was watching.

Across the table, a pair of bright black eyes was gazing back at him, set above a beaky nose in a homely red-cheeked face. This odd little faery had three hands—one on the end of each thin arm and one stuck on the top of his head. A borrower! Sneezle had heard many tales about borrowers before, but he'd never seen one in the flesh. They didn't like to be seen.

Between one blink of the eye and the next, the beaky face had disappeared. Sneezle rubbed his eyes, wondering if he'd really seen it. A borrower!

The band struck up an *estampie* and the king bowed low before his queen. "Will you lead the dance, my lady?"

"With pleasure, my lord," Titania answered.

The crowd parted to let them through, the queen's long skirts trailing through the grass, her hair braided with golden threads, adorned with tiny flickering stars. Lords and ladies lined up behind, following with careful, dainty steps in a dance that was old as humans reckon time but still fresh and new to the faeries.

Released at last, Twig dashed to his side. "Don't you look handsome tonight!" she exclaimed.

He blushed as red as his new tailcoat. "Do you think so?" he asked shyly.

"Oh yes! You'll dance with me, won't you, when they play the jigs and elfin reels? And I want to sing with the piskie choir. What do *you* want to do?"

"Eat!" said Sneezle.

Twig laughed at him. "We'll dance, sing, *and* eat, don't worry. And play Hobgoblins, and Bury the Berry, and a match of Chase the

Rabbit, too. Your uncle Starbucket is here, you know, and my aunty Pod, and, oh, everybody! My aunties flew all the way from the marsh to see me serve the queen."

Never before in the history of the wood had a faery from Eastern Marsh obtained the rank of royal handmaiden to the faery queen. Twig had been rewarded with the job for saving the queen's Midsummer crown (since no one knew it had actually been Sneezle who'd carried it safely through the forest). Rianna had been the fourth handmaiden then, a wicked faery who had tried to steal the crown. Now Rianna was banished and the marsh thistle faery had taken her place.

Sneezle was proud of Twig's royal post, but Twig was embarrassed about all the fuss—particularly since she knew she wasn't good at her new job. While all the other maidens served the faery queen with effortless grace, Twig spilled wine and braided Her Majesty's hair into tangled knots. Nonetheless, she knew that all her aunties in Eastern Marsh were thrilled and so she ignored the tittering of the court ladies and tried her best.

Twig smoothed out her crumpled wings and said, "Look, Sneezle, the dance is ending."

"Then can we eat?" he asked hopefully.

"First Titania will make a toast and *then* we can eat," she assured her friend. "Quiet, now. It's time for the queen to speak. Oh, I love this part!"

Together, the king and queen mounted the steps to the throne of Old Oak Wood, sharing its seat between them as was the custom of the forest. The king beckoned to the chamberlain to bring his drinking cup forward. The chamberlain nodded, turning to the king's royal cupbearer.

The cupbearer was trembling. "I can't find the cup!" the elf whispered.

"The king left it right by the Midwinter cakes," the chamberlain told him sternly.

"But it's not there anymore," squeaked the elf.

The chamberlain scowled down at him. "Then find it at once! Royal cups don't walk away or vanish into thin air!"

"I've looked! It's gone!" wailed the cupbearer. "I swear, it *did* vanish into thin air."

The chamberlain's wings twitched anxiously as he searched the High Table himself. The table was crowded with drinking cups of silver, rainbow glass, and wood—but Oberon's beautiful amethyst cup

was nowhere to be seen.

"Well?" snapped Oberon, annoyed. "Bring me my cup for the Faery Queen's Toast!"

The chamberlain swallowed, his wings drooping. "The royal cup is missing, my lord."

"*Missing?* My favorite drinking cup? I've used that cup for six hundred years!"

"It appears that your cup has been moved, my lord," said the chamberlain miserably.

"Moved? By whom? Where's my cupbearer?" roared Oberon, looking angry now. His temper was famous, and even the elfin knights avoided his gaze.

The cupbearer pushed through the court and knelt before the faery king. "I l-left the table," he stuttered out, "to watch you dance with 'er Majesty. And when I came back, Your Magnificence, the amethyst cup was gone."

Oberon stared at the elf darkly, then waved him away with an impatient hand. "Someone has taken my cup, disrupting the Midwinter rites and displeasing me. I demand to know who would dare such a thing. Come and show yourself to me!"

The courtiers looked at one another, perplexed. The serving gnomes all shook their heads. A murmur ran through the crowd, for such a thing had never happened before. The king's gray eyes flashed dangerously. He gestured to his elfin knights. "Search the glade. We shall not feast until my cup is found."

Titania put her hand on his arm. "My love, stop and think," she said urgently. "The Midwinter rites have begun. You mustn't stop them because of a cup!"

"My *favorite* cup," he growled at her. "It was made by Wayland, the great faery smith."

"Wayland made hundreds of cups," soothed the queen. "I'll get you another one."

"I don't want another one—I want my own!" said Oberon, pounding the throne. He pointed to an elfin knight. "You, there. Go and find it!"

But the elfin knight, passing through the crowd, could find no trace of the royal cup. The courtiers gazed at one another, shocked. Who would steal from the faery king?

"*Goblins,*" ran a whisper through the court. Goblins delighted in mischief and theft. But surely no goblins would dare to step into the faeries' sacred grove—unless they'd come in secret to spoil the Midwinter celebration.

Titania frowned. It would *not* be spoiled. This year of all years, it had to go right. Oberon's temper, though sharp as thorns, was also as changeable as the moon. Thinking fast, she turned to her lover and smiled up at him.

"My lord," she suggested, "you want your cup found. Let's make a game of it, shall we? A royal quest for Midwinter's Day. Let's see who can find it first."

"A game?" The king's eyes lightened, his anger passing as quickly as it had come. Oberon was a sporting man and Titania's idea intrigued him. He stroked her hand, considering, and smiled back at his lovely queen. With a flick of his fingers, the faery king brought the elfin knight back to his seat.

Titania rose to face the crowd, her hair turned silver by the moon, her skin as white as milk, her velvet dress as red as wine. "I propose a quest," she cried, "for Midwinter's Day!"

A ripple went through the court. A quest! All faeries love a good quest, and they listened to her eagerly.

"The king has lost his favorite cup, made of faery gold and amethyst. Whoever finds the cup shall win a fine Midwinter prize. The quest will start tomorrow, good friends—when this night's revels all are done. For now: eat, drink, be merry. The Hunt for the King's Drinking Cup starts at dawn."

She turned back to King Oberon. "Your bauble shall be found, my love. But look, here's a humble acorn cup. I shall use this cup for the Faery Queen's Toast."

The faery king said gallantly. "In your hands, my dear, it's as fine as gold."

She gave the cup to the chamberlain, who filled it with Midwinter wine. Then he passed it back to the faery queen, who raised it up to the stars.

She said, "I drink to the moon, the stars, the ice, the snow, and the pale winter sun. To the change of the seasons, to winter, and to the renewal of life in the spring!"

The gathered faeries raised their cups, shouting, "To renewal! And to our queen!"·

The band struck up a lively air and the Midwinter feast resumed.

As the chamberlain wiped his brow with relief, Twig turned to Sneezle, her eyes shining. "Oh, isn't Titania wonderful? The queen always knows what to do. I think she must be just as smart as a sorcerer. Don't you think so, Sneezle?"

But Sneezle wasn't listening; he was thinking about the missing cup. Bright borrowers (his uncle Starbucket said) were the light-fingered thieves of Faerieland, attracted to anything that glittered brightly, like amethyst cups. It could hardly be coincidence that he'd just seen one sneaking around.

"Twig," he exclaimed, "I'm going on that quest. I know how to find the cup!"

He told her about the borrower, and Twig bounced up and down, excited. "So all we have to do," she said, "is find our way to the borrower's lair—"

"We?" Sneezle interrupted. "Won't you have to stay to serve the queen?"

"Tomorrow's a holiday, silly. And I've never been on a quest before! We'll have such fun! We'll start at the crack of dawn and be home by teatime."

"But quests can be rather difficult." He frowned at the slender marsh faery, remembering his journey six months ago to fetch the faery queen's crown.

"If *you're* going, I'm going, too," his friend insisted, hands on her hips.

"All right, all right," Sneezle quickly agreed, for he recognized Twig's stubborn look. At least borrowers weren't dangerous. "We'll leave as soon as it grows light."

As the two shook hands to seal this plan, a horn fanfare echoed through the trees and a troop of serving gnomes appeared bearing wicker trays piled high with food: toadstool pie, baked goblin fruit, sweet honey cakes and crab-apple cider. Young Sneezle shivered with pure delight as he crossed the glade, arm in arm with Twig. Tomorrow would be quite soon enough to think about cups and borrowers. Tonight they would eat, drink, and be merry. It was the queen's command.

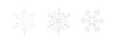

Despite the plan to set off at dawn, it was almost noon before they woke beneath the empty feast tables, and then the two young faeries stopped at Sneezle's house for a spot of breakfast. Nonetheless, Sneezle and Twig were confident they would win the hunt—for, unlike the royal courtiers,

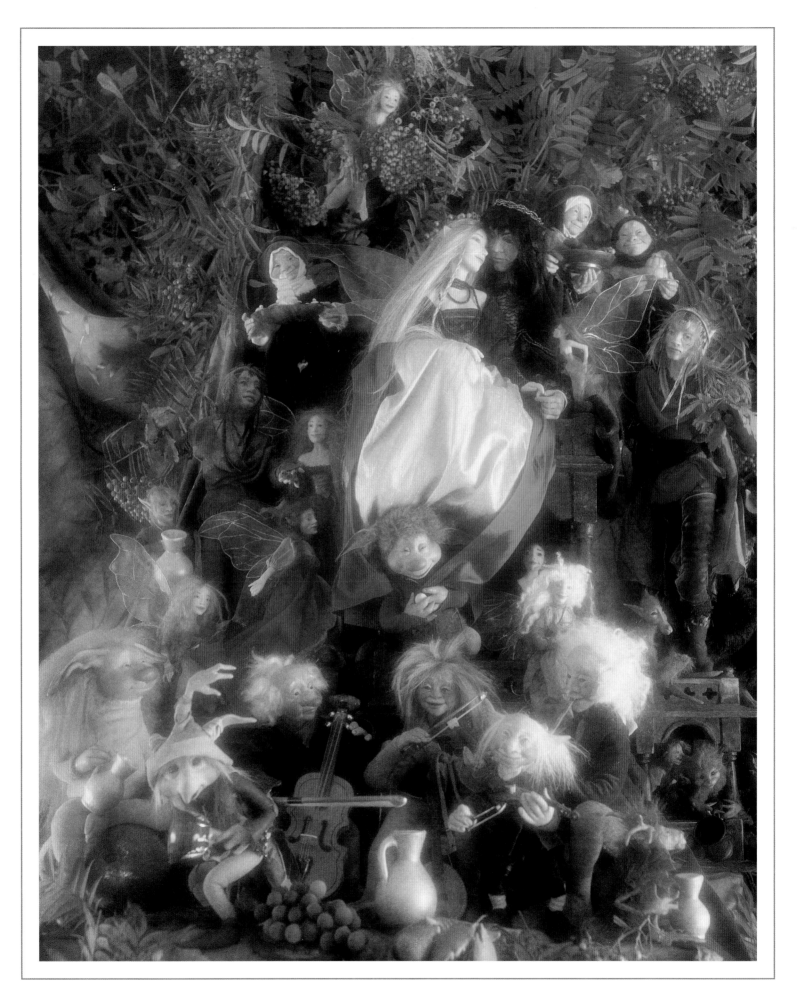

they knew who they were hunting.

Sneezle packed acorn bread, blackberries, and cake into his traveling pouch, along with a magic hazelnut wrapped up in a handkerchief. This was the only magic he had left from his quest to save the queen's crown. He didn't want to use it up, but it was best to be prepared.

"So where would a borrower go?" Twig asked her friend, finishing her toast and jam. She hoped it wouldn't be a *long* quest. She was feeling tired and sore already from last night's match of Chase the Rabbit, which those blasted rabbits had won by scoring two points in the very last seconds.

"Borrowers live in the western woods," said Sneezle. "He could be anywhere, but I know somebody in those woods who might be able to help us."

"I've never been to the western woods," said Twig as the pair left Greenmoss Glen, climbing a ladder of roots to an overgrown path through the trees above.

"I don't usually go there either," said Sneezle, "because of the goblins."

"Goblins!" Twig exclaimed, alarmed. "We won't go *that* far west, will we? I hate goblins. They used to raid the marsh when I was small."

Like all young faeries, they'd both grown up hearing tales about the Goblin Wars. Even though it had all happened long ago, no faery quite trusted the goblins anymore. The good ones were unpredictable and the bad ones . . . oh, they were wicked indeed. Sneezle didn't plan to go to the western hills where the worst of the goblins lived, but borrowers were known to dwell in the alder groves close to those hills—so they'd go as near to the goblin lands as they dared, find the cup, and hurry home.

The narrow path looped through the trees, twisting, turning, uphill and down, and it took them half the afternoon just to reach the western forest. Here, the trail divided around a tall finger of standing stone carved with mysterious elfin symbols dating back to the Goblin Wars. The right-hand trail led to the heart of the wood, where the old Tree Oracle lived—but they wouldn't find their borrower up there, among the sacred oaks. No, the creature was bound to be in the dark, dank wilderness ahead; and so they took the other trail and slowly plodded onward.

Twig looked around her warily. A roof of leaves blocked out the sun; cobwebs draped the undergrowth, binding bracken and thorn together. She broke the gloomy silence, asking, "Sneezle, who do you know out here?"

"A tree elf who lives just ahead. I met him on my quest last summer. He knows these woods. He'll know where alder trees are growing and if borrowers are nesting in them."

"The borrowers build nests?" asked Twig.

"No," said Sneezle, "they 'borrow' them. They like bird's nests in alder trees, but if they can't find any of those, they'll look for nests in oak trees, or even use an animal's den."

Twig turned her gaze to the branches overhead. "Do borrowers have floppy ears?"

"Uh-huh, they do. And floppy hats." Sneezle peered into a rabbit hole. Nope, no borrower down there.

"Do borrowers have furry tails?"

"Uh-huh. And furry feet," said Sneezle. He looked into a hollow log and a small hedgehog stared back.

"And beady eyes?" asked Twig.

"Uh-huh."

"Then there's a borrower!" she cried.

Sneezle looked up through the tangled trees where a face was peering down at them. "That's no borrower!" he said, smiling. "That's the elf we're looking for. Hey there," he called. "It's me! It's Sneezlewort Boggs! Remember me?"

The tree elf waved, balanced like an acrobat on a slender, swaying bough; then he jumped from branch to branch as lightly as a cat till he reached the lowest. He was dressed in fine Midwinter clothes, sporting a handsome new red cap, but Sneezle recognized his wrinkled brown face and his beetle-black eyes.

"Yup, to be sure, I remember you, laddie," the elf recalled, peering down at the boy. "First met you at Midsummer, I did. We was helpin' them ladies to polish the stars. No head for heights, as I recall. What brings you back to this neck o' the woods?"

"We're on a quest," Sneezle said grandly. "A mission for King Oberon. This is Twig, my friend, who is handmaiden to the faery queen."

"My word!" The tree elf quickly removed his cap and bowed respectfully.

"Oh, please don't bow," said Twig, embarrassed.

"I'm honored to meet you," said the elf.

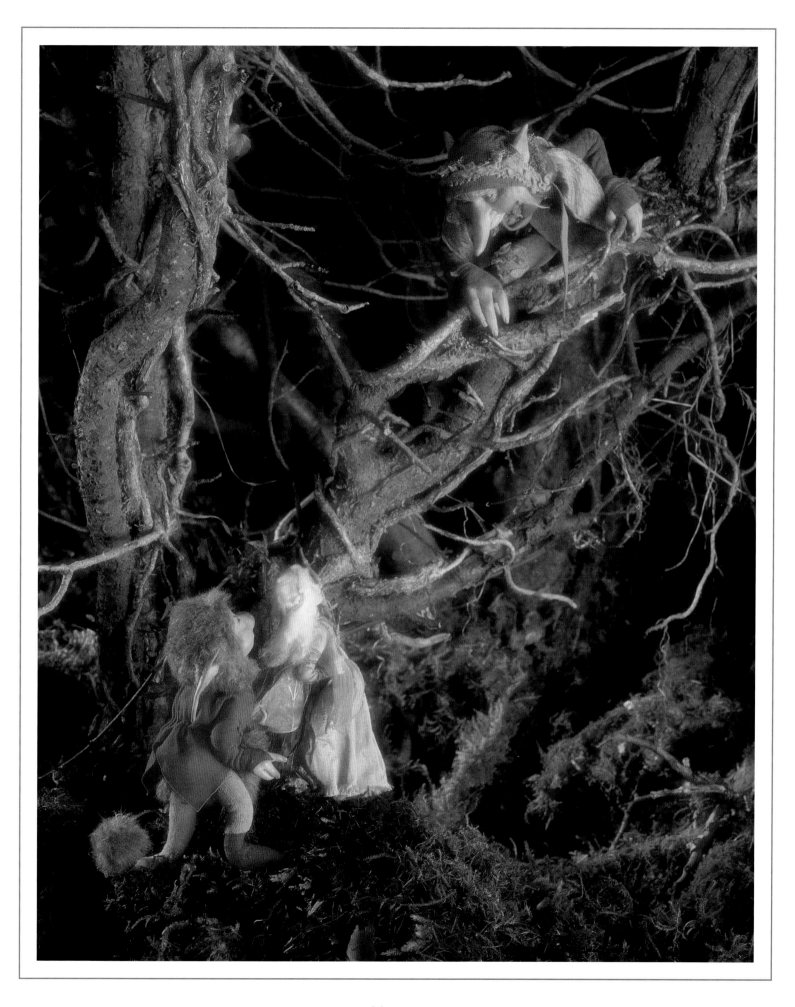

"Don't get many grand royal ladies down here. And you, laddie, you've found yourself a fine job. Why, I'm mighty impressed!"

Sneezle puffed out his little chest. "Yes, I'm a busy man these days. Right now I'm looking for borrower nests. We wondered if you could help us."

"Borrower nests? My stars!" said the elf. "Plenty of borrower nests 'round here. Borrowers got small brains," the elf went on, tapping his own forehead. "They fill a nest with treasure, forget where it is, then they fill another one. That's why they're called borrowers, did you know? They don't really mean to steal, no sir, they just want to borrow things for a while. But then they lose the nest, and so they can't bring anything back."

"Can you show us their nests?" asked Sneezle eagerly. "We're looking for the faery king's cup, you see. A borrower took it yesterday and I thought maybe you had seen it."

"Nope, can't say that I have," said the elf, "but tell me more about it, lad."

"The cup is carved from amethyst," said Twig, "with a stem of faery gold."

"Faery gold?" The tree elf frowned and rubbed his chin. "Now, that's a clue. Them borrowers don't like faery gold. They think it brings bad luck, you see. But I know one young fellow among them that doesn't hold with such ideas. I came across his nest not long ago—bursting with gold it was. Now, where was it? Just let me think. Alder . . . thorn . . . foxglove . . . wood shrews . . . ah yes, I remember perfectly! Just up this path you'll find a stream. Follow it down to an old stone weir. Below, you'll come to a stand of thorn with fine young alder trees among them. The tree you want has a nice family of shrews living at its roots."

"And you think we'll find the king's cup there?" asked Twig.

"I'd say it's the likeliest place. Any borrower would steal amethyst, but only one steals faery gold." The tree elf grinned from ear to ear, pleased with his own cleverness.

The faeries thanked the wrinkled old elf and watched him climb to the branches above, then the two companions hurried on, eager to reach the stream ahead. Tree elves, however, have little sense of distance, and the children walked another long hour before they reached the banks of a stream running swiftly over mossy black stones. The water tasted of mud and rust, but nonetheless it quenched their thirst as they ate a loaf with sweet blackberries and shared a last honey cake.

Now they followed the current of the stream, leading them farther and farther west where the dense greenwood seemed older, darker, more buried in ivy than ever. Despite the faery court's Midwinter rites, there was still no sign of winter here. Hazel and oak still bore their leaves; bracken had not yet turned to gold; and one old tree sported flowers and crab apples at the same time.

"'Flowers out of season, trouble without reason,'" said Twig. "That's what Aunty Pod used to say."

Sneezle eyed the crab-apple blossoms warily and quickened his steps.

They were too close to the goblin lands here. He wasn't quite sure where they began, but Goblintown was somewhere in the hills, in an old tin mine. All faeries avoided Goblintown, as did the gentle hobgoblins who lived among the faery folk, for the fierce goblins of the west were different, and worse, than the rest of their kind. The goblins of Goblintown had tried to claim the forest during the Goblin Wars—and even though they'd been defeated and pushed back to their underground realm, they still delighted in causing mischief and harm whenever they could. Fortunately, they were none too bright, and rather afraid of the elfin knights. Without a leader (their Goblin Prince had been slain in the final battle of the war) they tended to stay in their own part of the forest, fighting among themselves.

Imagining goblin eyes in every shadow, Sneezle followed the course of the stream till they reached a weir of old gray stones tumbled into weeds and water. Just beyond, as the elf had said, was a silent grove of bent thorn trees. At the center grew a cluster of slim young alder, standing straight and tall.

The tallest held a large bird's nest in the crook

of its branches far above. "That's it. Just where he said it would be," said Twig. "I'll fly up and look."

She spread her wings, beating the air, and rose high over Sneezle's head. Landing on a slender branch, she looked into the nest . . . and frowned. The nest was packed with knives, forks, silver platters, machinery parts, jewelry, shoe buckles, dragon scales, colored glass, and bright gold coins.

"Well, is it there?" Sneezle called up.

She shook her head. "I don't see the cup. But maybe it's buried underneath this junk. I'll have a look."

She picked up jewelry, platters, spoons, and threw them over the side of the nest. Underneath, Twig found a gold bracelet, a Big Person's watch, a golden egg, a copper teakettle . . . and there, just behind the egg, the amethyst cup! Twig reached for it, snatched back her hand, and stared at the nest, her mouth open.

"Twig, is it there?" Sneezle called again.

The marsh faery just sat and stared.

"Well, have you found the cup or not?" Sneezle was growing exasperated.

Twig looked down at her friend below. "Sneezle, I think you should come up here."

"Oh no," the boy called back, "I'm perfectly fine just where I am."

Twig launched herself from the borrower's nest and floated down to the forest floor. Hovering just above the ground, she grabbed Sneezle by his red tailcoat—and before he even had time to protest, he was high up in the alder tree, deposited on a branch that bent alarmingly under his weight.

Twig perched in the leaves above. "Look at that," she told her friend, pointing into the glittering treasure hoard in the borrower's nest.

"Yes, I see! The cup!" he gasped, clutching the alder branch tightly.

"No, I mean look at that egg!" Twig pointed again. "Did you see it move? There's a crack in it, and it's getting bigger." Her eyes were bright as she turned to Sneezle. "I think that egg is hatching!"

They watched as the crack in the egg widened. It rocked gently from side to side . . . and then a second crack appeared. The egg rocked violently now, the gold shell slowly separated, and then the top half shattered.

A baby lay curled up inside, soft and downy as a newborn chick. She rubbed her face with tiny little fists and slowly opened her eyes.

"A baby faery," whispered Twig. "I've never seen one hatched from an egg!"

Faeries, they knew, were usually born from earth or wind or water or fire. But this little creature was certainly a faery. What else could she be?

Sneezle's voice came out in a squeak. "Look, Twig! She's changing, she's . . . she's . . . *growing*." And indeed she was, growing right before their eyes, stretching out her milk-white limbs, uncurling her little fingers and toes, and turning from a downy newborn into a tiny, perfect child. Her hair turned to a feathery green, her eyes darkened, her ears grew pointed. She sat up slowly in the shell, and then her face popped over the top. The first thing that she saw was Sneezle. She hiccuped, and smiled at him.

Sneezle felt a lump in his throat as he sat astonished, staring at her.

"Look, she's cold, she's shivering," Twig crooned. "Oh dear, the poor little thing."

Sneezle swallowed and found his voice. "What are we going to do with her?"

"Get her into some nice warm clothes, of course."

"I mean, what should we *do* with her? She must have been stolen, like the cup. She must belong to somebody."

"Maybe she has a mother," Twig said, "like Big People and animals do."

Sneezle pondered this. He didn't know much about mothers. He only knew about faery clans—like his own respectable tree root clan, where elders were all called Uncle or Aunt. But this child hadn't sprung out of a tree, as he had; she'd been born inside an egg. "Is her mother a bird?"

Twig wrinkled her nose. "Her mother is a faery, silly. Birds don't have fingers and toes. She's got little rumpled wings, like me, but she's still too young to fly with them. It's a good thing we came along—how would she get down from this tree without us?"

Sneezle looked down at the forest floor and shuddered. It seemed very far away.

"Don't worry," said Twig. "I'll fly her down, and then I'll come right back for you."

She climbed down to the borrower's nest and lifted the baby from the shell. The child clutched

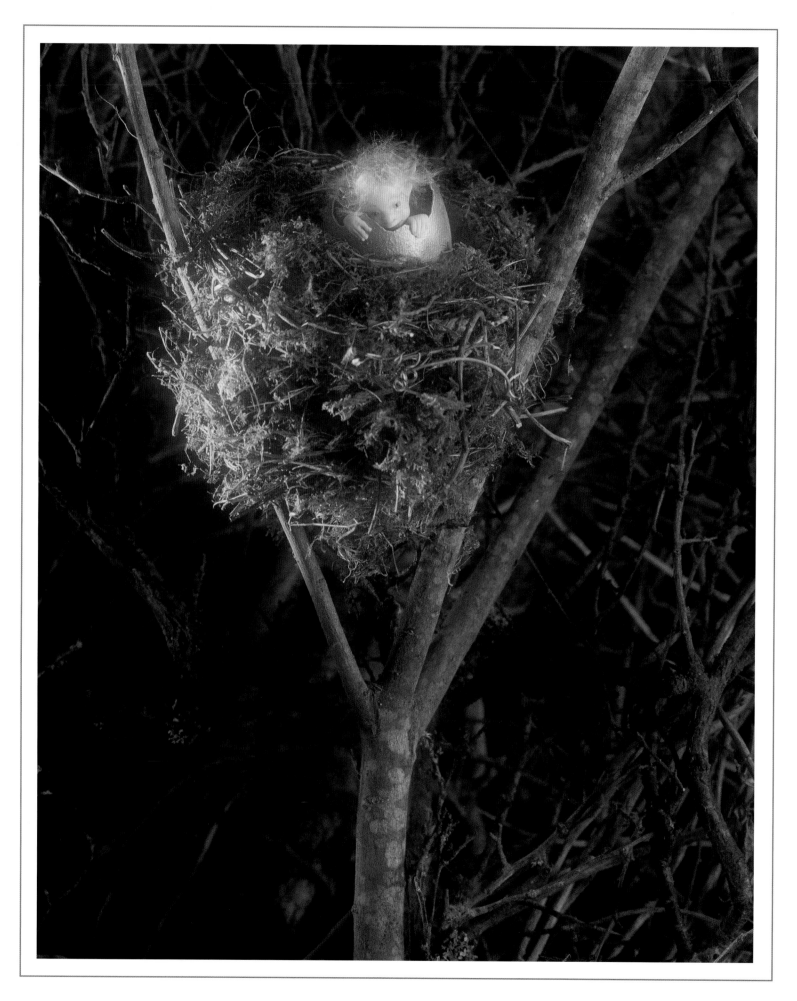

Twig's neck as they floated gently to the forest floor.

Then Twig returned to help her friend. Sneezle lifted his arms, his eyes shut tight. He hated heights. A tree root faery belonged on good, solid ground.

"Open up your eyes, silly!" she scolded. "You need to carry the cup. And here, hold this silver needle, too. Go on, take a nice deep breath."

She grabbed him around his plump, furry waist, then lifted him clumsily into the air. Twig pumped her wings, regained her balance, and flew smoothly back to earth.

The stranger child was watching them, her eyes wide in a pointed face, her pale skin tinged with blue now from the chill of the forest shadows. Sneezle jumped up, took off his coat, and quickly wrapped her up in it, then he fetched blackberries from his pouch and showed the girl how to eat them.

Twig, meanwhile, ripped cloth from her underskirt, teased out some long white threads, and then began to sew the cloth together with rapid stitches. She'd been an apprentice seamstress once, working in the royal tailor shop, and it wasn't long before she'd shaped the cloth into a raggedy dress.

Sneezle wiped berries from the baby's chin with his checkered handkerchief. "We'll have to take her with us, Twig. We can't just leave her here."

"Of course we can't," the marsh faery replied. "We'll bring her back to court. We'll take her to the queen—Titania always knows what to do." Twig knotted the thread, cut it with her teeth, then stood and shook the garment out. "This is for you, little chick. Your very first Midwinter frock!"

Twig fitted the dress onto the girl, then stepped back to admire it. Soon, the child stopped shivering and her skin took on a rosy glow.

"Come along now, chick," said Twig gently. "Here, take my hand. Can you walk?"

The girl stood up on wobbly legs, awkward as a newborn colt. She took one step, and then another, then suddenly sat back down.

Sneezle applauded. "Not bad, for a start! But I think we'd better carry you, Chick. It's a long way home and we need to be out of this part of the woods before nightfall."

He settled the child on his back, her little legs wrapped around his waist. Twig carried King Oberon's cup and Sneezle's pouch as they turned toward home.

Retracing their steps, they made their way upstream to the edge of the crumbling weir. Mist rose from the dark water and the air was turning dusky now. Fireflies flickered in the trees; a single bird called mournfully. Wind rustled in the leaves above, causing the shadows to move and grow. . . .

No, no, not shadows, Sneezle realized. Goblins! Big, ugly ones! There were two of them, wearing pointed helmets and holding iron-tipped pikes.

"Well, what have we here?" said the first goblin as he stood blocking the forest path. He was the taller of the pair with a nose like the muzzle of a wolf.

"I think we just caught us some faeries," said the second goblin, who was even more vicious looking. He spat on the ground between them and grinned, revealing jagged teeth.

"We want no trouble," Sneezle said quickly. "We were just leaving, so please let us pass." He was glad his voice didn't sound like a squeaking mouse, which was how he felt.

"'Flowers out of season, trouble without reason,'" said the smaller goblin nastily.

"You've been following us!" Twig accused the one who was quoting Aunty Pod to her.

"We was following that borrower," the first goblin informed her loftily. "We was looking for his treasure hoard . . . and you two led us right to it!"

"We caught the critter once last week, but he got away," said the smaller one. "He had a nice fat egg made out of gold. We want it! Hand it over!"

"And everything else you found in that borrower's hoard," the first goblin demanded.

Sneezle stepped back. "We're on a quest for King Oberon, so let us go."

"We don't care about your poxy king," said the small goblin. "We care about gold! Gimme that cup thingie you're carrying there! And where's the egg?"

"The egg is cracked, for your information," Twig retorted, eyes snapping angrily. Clearly no one had ever told her that you should never argue with goblins. "There wasn't any gold inside it. The shell is still in the borrower's nest. So go and get it, and leave us alone."

The big one grabbed her by the arm. "Nothing inside that egg, you say? But it was heavy! You're hiding something." His beady eyes moved to the child. Golden shell clung to her hair. "Where did

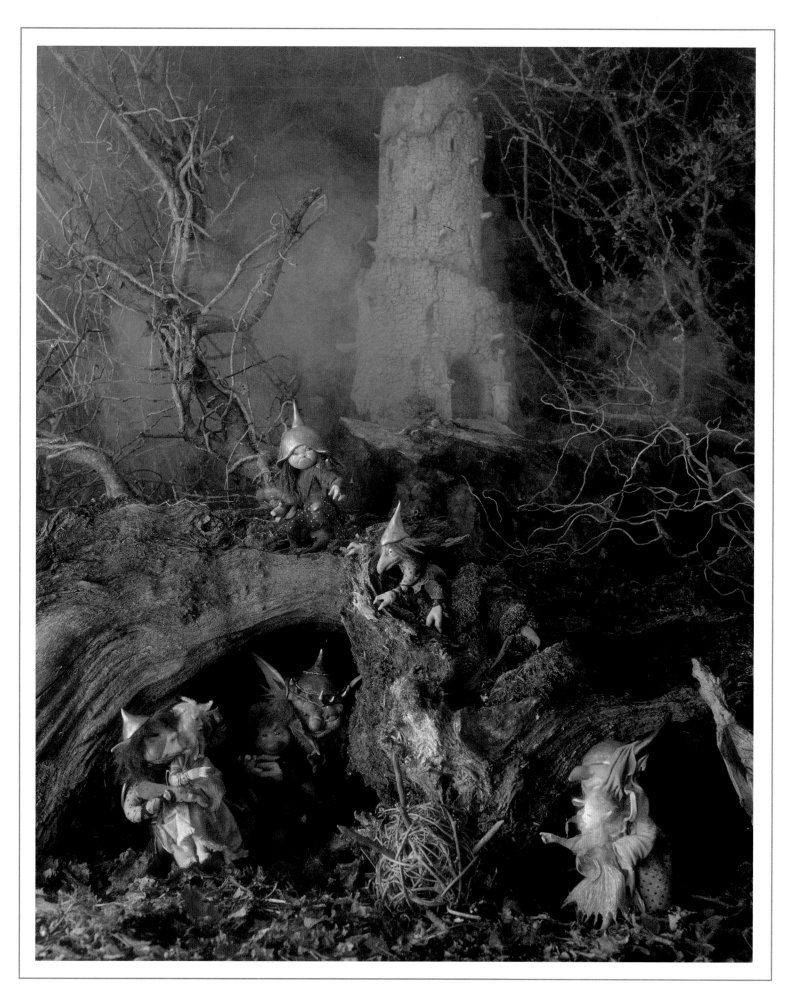

that baby come from, then? She didn't come to the grove with you—you brung her out of that borrower's nest. *She* was in the egg, was she? It was some kind of magic egg, wasn't it? Well, she belongs to our master now. You all do. Three juicy young faeries. Maybe he'll keep you, or maybe he'll sell you off in the Goblin Market."

"Run!" cried Sneezle. He bolted back to the grove, the baby clinging tightly. Sneezle heard Twig cry out behind and the sound of wings beating the air. A goblin cried, *"She bit me, she did! Get her!"* He ran as fast as he could. But there were goblins, goblins everywhere, a whole troop of them surrounding the grove. The baby was breathing in shallow, frightened gasps. There was no way out.

Sneezle turned and faced the tallest goblin, who seemed to be in charge. "Let the baby go," he begged. "What use is a baby? Take me instead."

"Oh, don't worry, we'll take you," the goblin agreed, "and the girl and the baby, too. Our master is going to want you all. Yes, he'll be pleased with us this time."

Sneezle bit back a cry of despair when he saw that Twig had been captured, too, her arms pinned by a squat goblin with a face like curdled milk.

The goblin captain signaled his men. "Guard them. And watch that girl—she bites. Somebody climb that tree and get the rest of the borrower's treasure!"

A rat-tailed creature grabbed Sneezle's pouch from Twig and dumped its contents on the grass. The magic hazelnut rolled out, unnoticed among the blackberries. The goblin stamped on the empty pouch, then stupidly looked inside again, bellowing with rage when the pouch remained empty of treasure. Sneezle looked longingly at the magic nut discarded on the ground. If only he could reach it, then he could wish them all to safety.

The borrower's hoard was put into a sack strapped to a goblin's back—the smallest of the company, who staggered under its weight. The soldiers then marched their prisoners through the darkening woods on an unmarked trail. Twig hissed and spat like an angry cat in the grip of a burly, weasel-faced guard; the baby was carried upside down; and Sneezle stumbled along behind, prodded by the iron-tipped pike in the rat-tailed goblin's hands. The soldiers spoke in gruff Goblinese, except when barking orders at them, so he couldn't tell where they were going or even who their master was—but soon he saw their destination rising through the bleak thorn scrub: an old and broken tower looming on the far horizon.

In a dark, foul-smelling hollow just below the tower, an argument broke out, and the vicious little goblin went red with rage, shrieking at the others. The goblin soldiers hissed and jeered as the captain kicked the vicious one. The smaller fellow gave a bloodcurdling screech and attacked the captain.

The goblin troop came to a halt.

"You! Sit!" Rat-tail ordered, pointing his thumb at Sneezle as the cries of the fight grew louder.

Chick was dumped into Sneezle's lap and clung to him, clutching his coat, as Rat-tail trussed his knees and the baby's feet with a scratchy rope. Weasel-face used a silver chain from the borrower's hoard to lock up Twig. Then the goblins joined the other soldiers to watch their fighting comrades.

The vicious one was soon rolling on the ground beneath the captain's blows, and the captain pushed his face into the dirt, teeth bared and growling. Sneezle stroked little Chick's soft hair. She was shivering again, but not with cold, and he wished he knew what he could do to save her from these horrid creatures.

From the very corner of his eye, Sneezle spied a movement in the trees . . . and then he spied a small brown face. It was the borrower! Had the elusive faery come to their aid—or was he just following his hoard? Sneezle glanced back at the goblin guards, but they had eyes only for the fight.

He looked back at the faery thief—and then he almost laughed out loud. The borrower was after the silver! He wanted the chain around Twig's waist! Quick as a flash, the master thief picked at the lock and opened it, then pulled the chain from Twig and ran, clutching his glittering prize. A soldier turned and looked at them, roared, and lunged at the marsh faery. She ran from him, spread her wings, beat the air with furious strength, and lifted herself above the trees, beyond the goblins' reach.

With one last look at Sneezle and Chick, Twig soared into the eastern sky. Sneezle bowed his head, whispering a desperate prayer to the Lady of the Wood. *"Let Twig be safe. Let her reach the court. Let her send some knights to rescue us."* And he prayed that once again the queen would know just what to do.

The tower door clanged closed behind them. Sneezle inched forward into the dark, holding the baby in his arms. Mercifully, she was fast asleep and couldn't see this horrible place.

"This way," ordered the rat-tailed guard, pushing him farther into the tower. Someone lit a torch and a crooked staircase was revealed. It wound upward against the tower wall, steep and treacherous.

They climbed the stairs, up and up, until at last they reached a filthy room that must have been at the very top of the ruined tower. The stairway had been cold, but the smoky chamber above was much too warm. Enormous logs blazed in a huge stone hearth, casting a shifting light on walls that were stained with age, mildew, and rust the color of blood. The room was crowded with tables, shelves, and objects that he could barely name. There were bottles and jars, beakers and bowls, snakeskins, feathers, crystals, bones, and things he had never seen before and whose uses he could not imagine. A workbench held big grinding bowls filled with powders of alarming colors. The floor was littered with leather-bound books, nibbled at by mice and trampled on.

In the middle of this unholy mess, so still that he'd seemed part of the room, was a tall old man with silver hair dressed in fine velvet and dragon-skins, although even this finery was mildewed, torn, and stained. He sat in a tattered brocade chair and did not move as they entered the room, except for his eyes, which rested on Sneezle and pulled the little faery closer.

The eyes shifted and picked out the goblin captain, who quickly removed his cap. "Please explain," said the seated man in a voice surprisingly soft and gentle. "You promised to bring me a golden egg. You bring a boy and a baby instead."

The goblin shuffled forward anxiously. "We got something even better, master." Then he turned his head. *"Where's the cup?"* he hissed to the others. *"Get the treasure! And get the cup!"*

The treasure hoard was dumped onto the floor before the seated man. The goblin captain bent down on one knee, presenting Oberon's cup.

The old man took the drinking cup and examined it closely with displeasure. "It's one of old Wayland's amethyst cups. Not one of his best ones, I'm afraid." He dropped it carelessly on the floor.

"What makes you think I'd want it?"

The goblin captain began to sweat beneath the tall man's steady gaze. "We heard them faeries talk, master. That cup belongs to the faery king."

The old man sniffed. "Then Oberon has appallingly bad taste, I fear. Come, come, where is the egg you promised? A golden egg is worth having—they're rare and useful in my spells. I don't need cups and forks and more excuses. Did you find the borrower?"

"Yes, sir. These two was following him as well, or not these two, another two. Him, that is. And a girl . . ."

"Go on."

"A girl, that's right. Toothy, nasty little thing. She led us right to the borrower's nest . . . but then, that egg, it broke, she says. That baby was inside of it, so we brung the shell and the baby too and this fellow and the treasure hoard. Girl got away," he admitted. "Mucky little marsh faery, no loss."

"The baby was *inside* the egg?"

The goblin nodded like his head was on a spring.

"Interesting," the old man mused. "Interesting. Come forward, son."

Sneezle stepped closer, carrying Chick, who was warm and heavy in his arms. The old man's voice was soothing, but his gaze was altogether different. If Sneezle could have disobeyed that voice, he would have taken the child and run away. He felt like a mouse before a snake as he walked slowly to the chair.

The man put out one long white hand and stroked the baby's pale green hair. Even in her sleep she flinched and cuddled closer to Sneezle.

"What's your name?" the man asked mildly.

Sneezle found he couldn't speak.

"Answer Master Malagan, boy," the goblin captain growled.

"S-s-sneezlewort Rootmuster Rowanberry Boggs the Seventh," Sneezle managed to stutter out.

"And the babe?"

He was silent.

"Interesting," Malagan repeated. "There's more to this than meets the eye. Born from a golden egg, you say? I've never heard of a faery like this—I'm sure there's nothing of the kind in any of the standard reference texts. A curiosity! I like curiosities, son. In fact, I collect them."

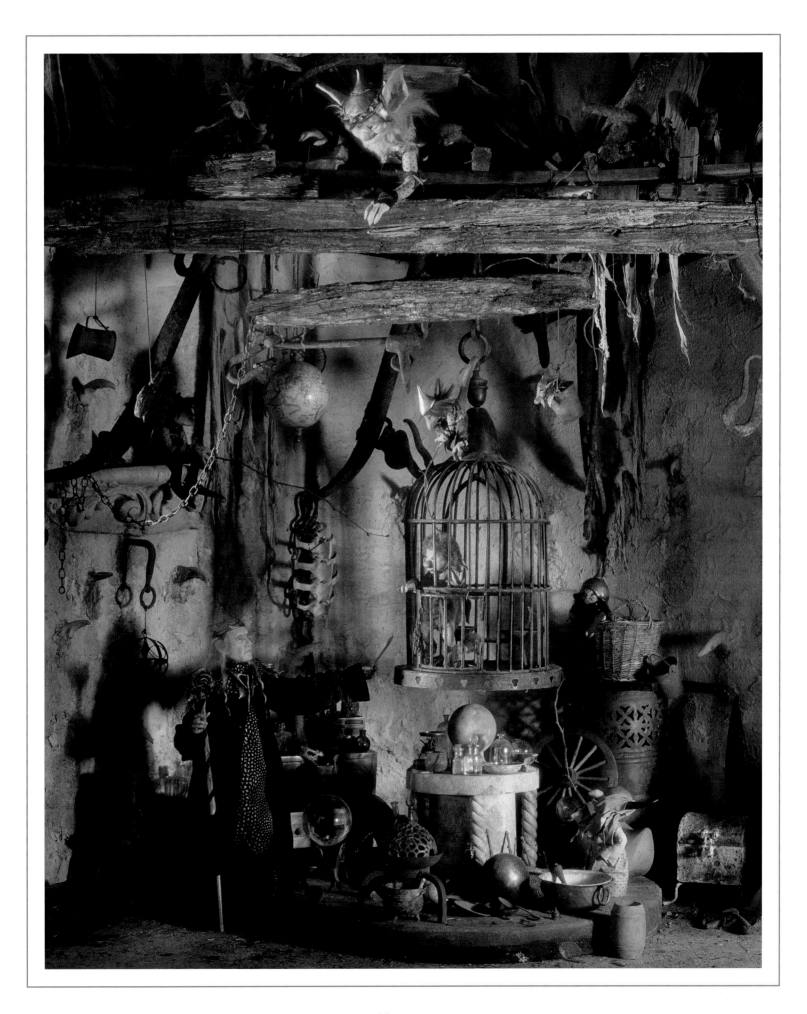

Malagan smiled—and his smile, like his gentle voice, was somehow terrible and *wrong*. Sneezle stood frozen to the spot, holding Chick as tightly as he could.

"You, on the other hand," the master went on, "are a common variety tree root faery. I'll keep the child—but you will have to be sent to Goblintown, I'm afraid. I simply have no use for you. I only collect extraordinary objects, and you're quite ordinary."

"I'm not just ordinary," Sneezle blurted out. "I was a hero once! I've been to the heart of the wood and saved the queen's Midsummer crown!"

It was the truth, but it sounded far-fetched as he stood trembling before the man. But he couldn't let them send him away and separate him from Chick.

Malagan laughed—a pleasant, almost musical sound. "A hero, are you, son? Next you'll tell me you slew the dragon of Exmoor or carried the sword Truesight! Captain, put our little hero in a cage. Gently, gently, gentlemen; we're not barbarians here. He'll fetch a better price in Goblintown if he's undamaged. And take the baby away from him—put her in the archives, if you please, and see that she's properly watered and fed, for she's going to require further study. Where's my book on golden eggs?"

Chick woke up and howled as Rat-tail tore her out of Sneezle's arms. He fought the goblins, flailing and kicking all the way to the door of a faery cage. They flung him in and locked him up behind its ghastly iron bars while Chick was carried from the room, staring back with sad, dark eyes.

"Hoist it, sir?" the captain said.

The faery cage lurched underfoot. A pulley screeched with a horrible sound and then the cage was hauled upward, swaying from a rusted iron hook in the ceiling beam.

Malagan rose from the brocade chair. He limped as he walked across the floor, leaning heavily on a staff of carved and polished oak. His eyes on the boy were speculative as he stood below the cage, frowning.

"One last chance," he said, "to tell me what you know about the child. Speak, and you might be useful after all. Speak, and tell me the truth."

He pointed to his prisoner with a wand like a painted chicken bone. Sneezle clamped his teeth against the power that seemed to flow from it. He wouldn't tell this wretched man anything about Chick even if he could. He wouldn't tell how she'd looked waking in the nest . . . or taking her first stumbling steps . . . or even the name they called her by. She wasn't a *thing* to be collected.

"Come now, son, this is foolishness. You, a little forest faery, pitting yourself against a sorcerer? There is nothing that you know that I won't soon discover, dear boy."

Sneezle refused to look at him. He dripped with sweat, but would not give in.

Master Malagan chuckled softly and limped away, shaking his head. "So be it, little hero," he said, as he left the room.

***

Eventually the fire burned out and the air, which had been too hot before, was now too cold. Sneezle's teeth chattered. He huddled in the cage and tried not to think what the morning would bring. Twice a goblin guard appeared, lighting the room with a stinking torch—first to set a bowl of goblin gruel at the bottom of Sneezle's cage and then to take it away again, completely untouched.

After a time, Sneezle fell into a fitful sleep, hungry and miserable. When he woke again the air was dark and cold, and yet he felt warm.

He sat up, startled. The baby lay at his side now, snoring delicately.

Earth and bones, how had *she* gotten here? He hadn't heard them bring Chick back. He feared that her appearance meant that she was now bound for slavery, too . . . but then, at least in Goblintown they might manage to stay together.

Curled protectively around Chick, Sneezle waited as the long night passed. Hours later, he smelled the stinking torch again and grimaced. Another goblin visit, he supposed. Goblin gruel for breakfast, too.

But it wasn't a goblin holding the torch, it was a small faery with a dirt-smudged face. "Twig!" Sneezle said as loudly as he dared. "Look! We're up here!"

"Oh, Sneezle!" The faery's eyes teared up when she saw her friend in the iron cage. "Oh, poor, poor Sneezle. Poor, poor Chick. Hold tight and I'll get you down."

She wrestled with the pulleys and gears and lowered the cage bumpily to the floor. The baby woke up and smiled happily to see Twig again.

Twig dropped the chain, rushed to the cage, and clutched Sneezle's hands between the bars. "Where do they keep the key?" she asked. "We've got to get you out!"

"Look inside that moldy old dragon head that's mounted on the wall. I've seen the goblins reach in there," said Sneezle. "And hurry, please!"

Twig pushed a pile of books across the floor, climbed up, and reached the head. "Got it," she said, clutching the key and clutching her churning stomach, too. Like all faeries, she could not abide the touch of cold, black iron. Nonetheless, she bravely took the key and carried it to the cage. And then she gave a cry of surprise, for Chick was crawling through the bars.

The child crawled right *through* the iron bars, as if they were made of smoke, then slowly stood, holding on to Twig's gold skirt as the others stared. What kind of faery could pass through iron? Sneezle bent to examine the bars, but they were solid to the touch and just as sickening as ever. He left the cage through the unlocked door and hugged his friend as tightly as he could. "Where are the others?" he asked her anxiously. "Waiting below?"

"What others?" Twig replied, puzzled.

"Didn't you go back to the court? Didn't you go and bring back help?"

"Go? And leave you and the baby here? Well, stars and whiskers, I couldn't do that! I crept behind and followed you and heard everything that the goblins said. And when those stupid creatures finally fell asleep, I crept up here."

"We're on our own?" Sneezle's voice grew high. "No warriors? No elfin knights?"

"Shhhhhh," said Twig, "you'll wake them up! Don't worry, I've got something better than that." She dug into her skirt pocket and pulled out a small brown hazelnut. It was *his* hazelnut—the magic

one, muddy and a little dented.

"The wish!" he said with sharp relief. They were going to be safe after all! "All right, now, let's think carefully. We only have one wish to use, so we have to use it wisely and make very sure there are no hidden tricks."

"I've been thinking about the wish all night," said Twig. "I've got loads of good ideas. What if we wish for a flying ship to sail us all to safety . . . or—"

"Stop!" cried Sneezle. "You've said a wish out loud, and you're still holding the nut! Don't you see? You've used it up!"

The nut was starting to glow.

Twig yelped and dropped it on the floor. It sizzled as it landed there, burning brighter, growing larger, and then it began to spin.

"I'm so, so sorry!" Twig hung her head. It was *his* wish and she'd ruined it. "At least we'll have a flying ship to sail in—is that so bad?"

"We could have wished ourselves safe at home right now, without a flying ship!"

"This will be more fun," she assured her friend, patting his shoulder.

The hazelnut continued to spin. It grew and grew, larger, larger, spinning and casting sparks of light. Then the spinning slowed and finally stopped. The children stared, confused. The nut was now a shoe made for a giant, carved from pale wood.

Twig scowled at it. "I said a *ship*, not a *shoe*." She sighed, and then admitted, "I kind of stepped on your hazelnut when I found it. Maybe I broke it?"

"Oh, great," Sneezle muttered.

"S—h—i—p," Twig said firmly.

The shoe obliged by sprouting a mast and a sail made out of paper.

"How can such a heavy thing fly?" Sneezle pulled his ears in agitation. "This is ridiculous! I think we'd better just use the stairs."

"It flies by magic, silly." Twig was entranced. She climbed into the shoe. "Hand me Chick and the amethyst cup. Hurry up—I think it's leaving!"

Twig was right. The shoe had begun to hover an inch above the floor. Sneezle pulled a threadbare tapestry from the wall to keep the baby warm, then he lifted Chick and the cup into the shoe, climbing in behind.

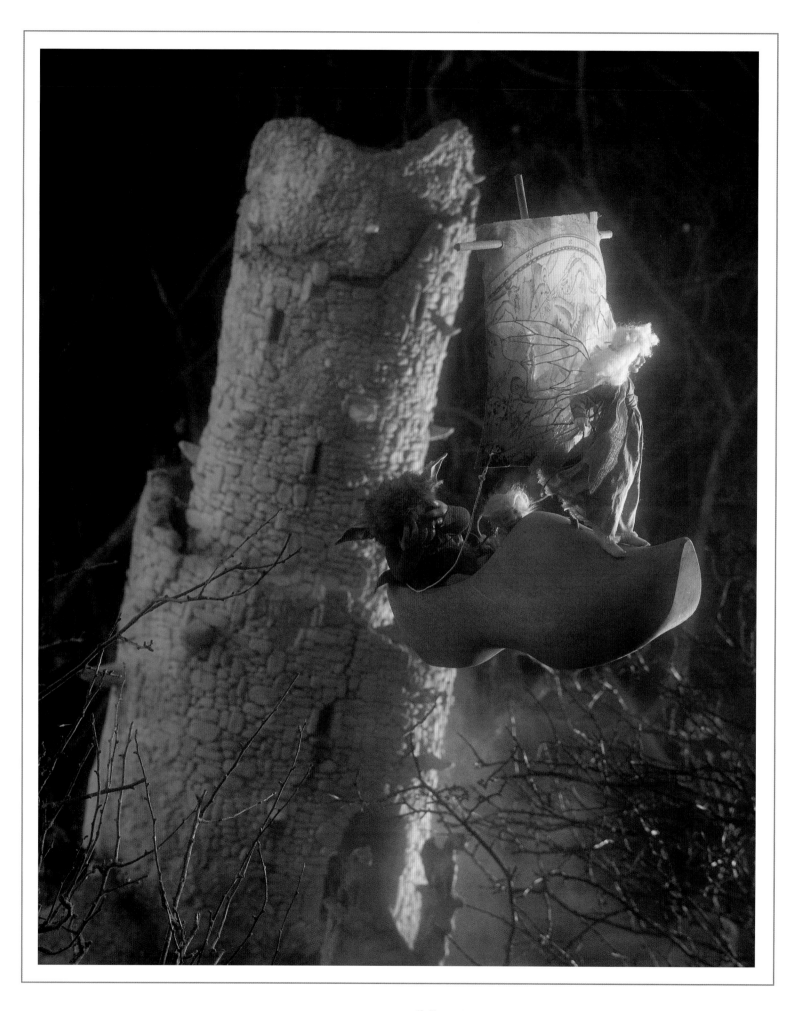

Twig stood braced on the toe of the shoe as it lifted clumsily into the air. It lurched, dipped, lurched again, and swooped over to the window ledge—where it paused as if gathering its nerve, then soared into the sky.

The wind rushed past their ears deafeningly. "How do we steer this thing?" Sneezle yelled.

"We don't," Twig hollered back at him. "We asked for it to sail us to safety, so that's what it's bound to do."

"Safety *where?*" Sneezle wanted to know, but his words were swallowed by the wind. He sighed and clutched the baby, his long brown ears streaming behind him.

The shoe skimmed over the tops of the trees, zooming past some startled geese and then past a flock of faeries, who tried to race it but soon gave up. Sneezle, with his fear of heights, decided that he'd better shut his eyes. He heard Twig screaming with delight. The baby laughed, clapping her hands. The shoe looped left, then right, then left. He thought he was going to be sick.

After what seemed like a long, long while to Sneezle but the blink of an eye to Twig, the shoe lost altitude and slowed to a gentle, rocking speed. The wind that had filled its sail died down, pushing them lightly here, there, like a falling leaf that twists and turns and eventually comes to earth. They landed with a heavy jolt on the grassy slope of an unfamiliar hill. Dawn was just a glimmer through the distant trees and a thick mist swirled.

Above them was a huge building with many rooms, all brightly lit. A dog was barking, alarmed, no doubt, by the giant shoe on the lawn.

"I don't know," said Sneezle, worried. "I've never seen this place before. Maybe it's another goblin den. Maybe we should just keep going."

But the magic shoe wasn't going to budge, and a bent old man was coming down the hill, followed by a scruffy dog who eyed them suspiciously. The man didn't *look* like a goblin, although he wore a pointed goblin cap. His ears came to distinctive points. A faery! But an awfully odd one.

"Welcome, welcome," the stranger said, "we've been expecting you to drop in. Perhaps not quite so literally, eh? You've made a mess of the croquet court. But never mind. Come, come, step lively, they're waiting for you above."

"Who's waiting for us?" Sneezle asked, puzzled,

as he lifted Chick out of the shoe.

The little dog sniffed the baby's feet and then began to wag his tail.

"Eh? What?" said the bent old man. "I'm just a little hard of hearing, you see. Speak into this." He held out an ear trumpet, and Sneezle asked the question again.

"WHO'S WAITING FOR US?"

"Who's baiting porridge? No one. Never heard of such a thing! Porridge for breakfast, worms for bait—never mix the two, not here."

Sneezle tried again. "WHOSE HOUSE IS THIS?"

"Two mouse kisses? Eh? What? Come along."

Twig grinned, then spoke into the trumpet.

"MY NAME IS TWIG," she said loudly. "THAT'S SNEEZLE, THERE, AND LITTLE CHICK."

"Eh? What's that? Step lively, miss." He ushered them up a steep stairway and through a door into a spacious hall. Then he announced grandly: "Fig, Weasel Bear, and Chicken Little are here!"

An arched wood door opened on their left. Inside they saw an elegant room of plum colored velvet furniture and shelves crowded with books. A stout old man in a long green cloak stood in the doorway, cap in hand. "Ah, children, you are just in time," he said. "Do come and join us."

"IN TIME FOR WHAT?" Sneezle began, and then added more quietly, "We've just escaped from goblins, you see, and we don't know where we are."

"Why, you're at the Royal Library, child. Goblins, you say? How perfectly dreadful."

"The library!" Twig breathed, her eyes shining and her cheeks flushed pink.

"A library? What's that?" Sneezle asked the stout old man suspiciously.

The old man sighed, shaking his head. "What *do* they teach the young these days? The Royal Library, my furry young friend, is only the most important collection of magical texts in Old Oak Wood. And the center of scholarship for the Royal Council of Sorcerers."

Sorcerers! Sneezle backed away, but Twig seemed to be excited now. She made a formal curtsy and said, "We're honored to meet you, sir."

The old man's face crinkled in a smile. He gave the marsh faery a bow, replying with perfect courtesy, "The honor is mine, mistress."

Twig took Sneezle by the hand. "Don't you see? These are *good* sorcerers. Not like that wicked

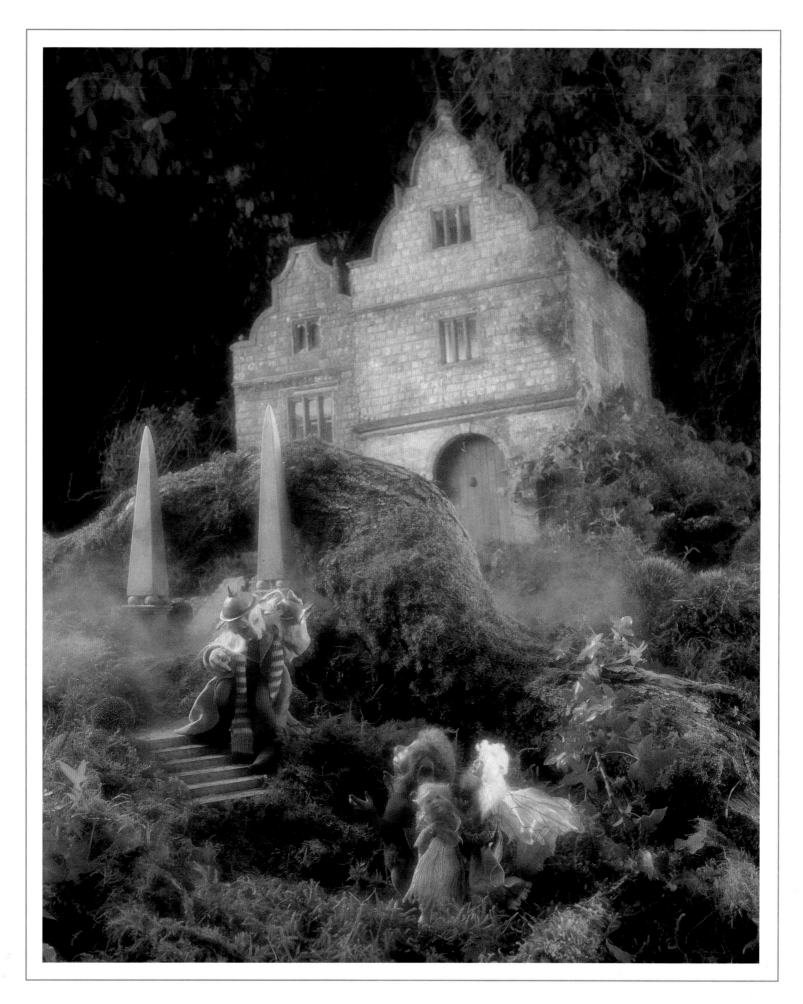

Malagan, with his nasty goblins."

"Malagan!" the old man interrupted. "Did you say Malagan? Oh, dear. But first things first, children. Master Beezwottle has put the kettle on, and, if I'm not very much mistaken, breakfast is nearly ready."

❄ ❄ ❄

They followed the sorcerer into the room beyond, which was softly lit by candlelight reflecting off the old oak walls and shelves full of arcane texts. Like Malagan's tower, this room held books and beakers and bowls and sorcerer's tools—but everything here looked clean, tidy, comfortable, and even cozy. A cheerful fire blazed in the hearth, warming the room to just the right degree, and a sorceress knelt before it, roasting sausages for their guests.

As Sneezle sat on the soft hearth rug, with Twig and Chick on either side, he counted seven sorcerers in robes of varying colors. Each of them was as old as time, as old as the oaks at the heart of the wood. One blinked behind thick spectacles; another was hunched over his cane; a fat one in a long red robe seemed to have a cold and kept blowing his nose; and the thin one right behind him looked as if the wind could knock her over. Sneezle had never pictured a group of sorcerers looking quite like this. Why, even that wretched Malagan had seemed more awe-inspiring. And yet one thing he'd learned at the heart of the wood searching for the faery queen's crown was that appearances can deceive, especially in a faery forest.

As tea was poured and passed around, the man in green made introductions. He himself was Brambleburn, the Council's Chief Librarian. Beezwottle, Master of Maps, was the fat man with a cold. The woman with spectacles, in purple, was Tamaryst, Mistress of Prophetic Arts; the gentleman in blue behind her was called Master Alderrod. This tall old man, the children learned, was First-staff of the sorcerers—which meant that he was leader of the Council, and the best of them. One by one, the others were introduced to the three young travelers, all dressed in the colored robes representing their area of scholarship. To Sneezle, they seemed much like the books that filled the Royal Library, with old, musty, faded covers hiding mystical knowledge within.

At Brambleburn's request, Sneezle told the tale of how they'd gotten here, from the borrower and the king's lost cup to the goblins and Malagan's tower. When he got as far as the flying shoe, Master Alderrod interrupted. "Ah yes, this part we know already. Mistress Tamaryst will explain."

"I saw you in my crystal ball," the sorceress in purple began, but before she could finish the sentence, all the others were chiming in.

"A simple mistake—"

"Looking for a missing shoe—"

"Found your flying ship instead—"

"Coming from the west—"

"Startling the geese—"

"Precisely in our direction, you see—"

"So Beezwottle woke up Stin—"

"The doorkeeper—"

"And Barnacus—"

"The dog—"

"And put the kettle on—"

"And here you are! More tea, anyone?"

Brambleburn refilled their cups, then sat back down by Tamaryst. Alderrod slowly paced the floor, his long hands clasped behind his back, for he was a man who could never sit still and even walked in his sleep. Sneezle sipped tea gratefully. It was milky and sweet, warming his belly. Twig helped Chick with her cup, and she smacked her lips, demanding more.

"What a charming little creature she is," the Chief Librarian commented. "I can't quite place the genus, however. Moss maiden? Fiddlehead fern clan? No, no, don't tell me, I'll get it . . . I'm good at this. . . ." He snapped his fingers, thinking.

"We don't really know," Twig told the scholar. "She popped out of a golden egg. We found her in a borrower's nest with old jewelry, forks, and spoons."

"Goodness!" said Master Brambleburn. "Born from a golden egg, you say? Most unusual. I'll have to consult the books. What say you to that, Beezwottle?"

"Too sturdy to be a changeling," said the man in red, blowing his nose again. "Hair too green for a mortal child. A faery, surely. Look at those ears! Those wings! Perhaps some obscure clan . . ."

"That awful Malagan tried to collect her!" Sneezle said indignantly.

"Well, yes, hmmm, Master Malagan . . ."

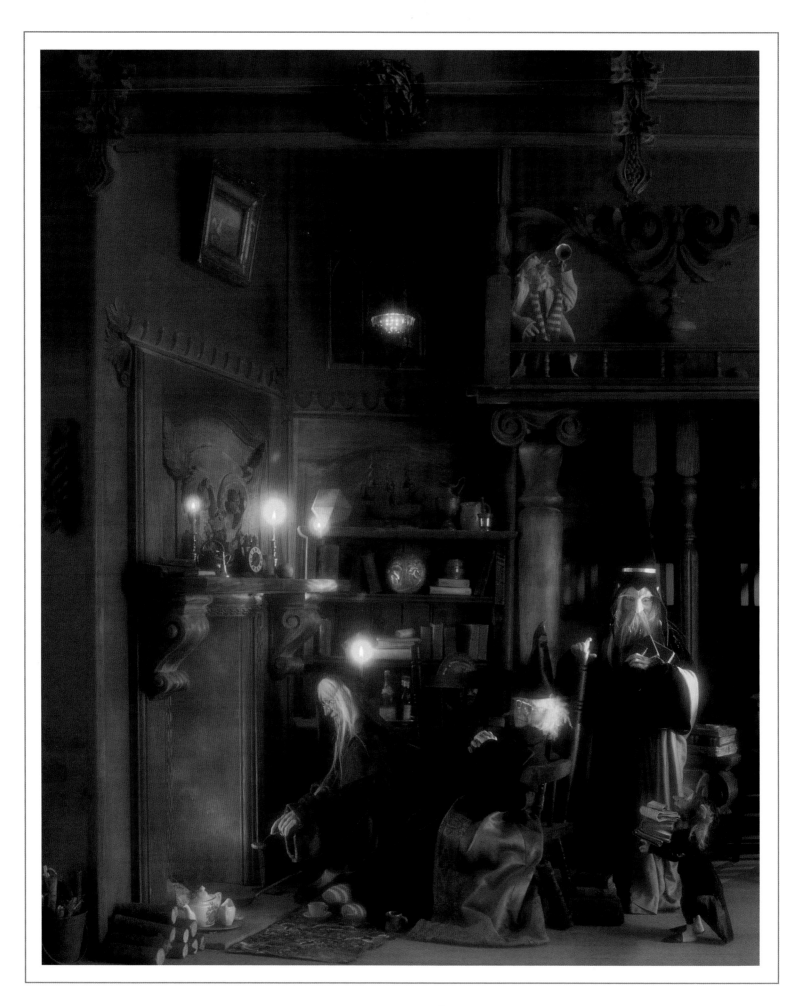

"Rather a disappointment to us—"

"Positively faked that paper on variant elfin rhyming-spell meters—"

"So of course the Council asked him to resign—"

"With deep regrets—"

"And severance pay—"

"But he took it rather badly and seems—"

"To have gone—"

"Downhill—"

"Into the dark arts—"

"Absolutely evil now—"

"A pity—"

"A shame—"

"So brilliant once."

"Malagan used to be one of you?" Sneezle asked the gentle scholars, astonished.

Tamaryst nodded sadly. "Malagan was First-staff of the Council of Sorcerers for many years—a dazzling scholar in his day and a hero in the Goblin Wars. But we were deceived in him, it seems. Brilliant but unscrupulous. No true scholar would publish false material, even on the minor elfin art. . . ." This old memory seemed to cause her pain and her voice drifted into silence.

"The Council was forced to strip Malagan of his higher degrees," finished Master Brambleburn. "The man was sent packing."

"Such a waste of a mind," murmured Beezwottle.

"We've heard very little of him since he left the library," said Alderrod, pacing by the windows now. "He publishes no papers, attends no wizardly gatherings—he's quite out of our orbit. But the rumors one hears are terrible. Consorting with goblins. Practicing dark arts. Can these rumors possibly be true?"

"Absolutely," said Sneezle. "Malagan put me in a *cage.*"

"He's got a goblin army working for him," said Twig. "He's building his own library. The goblins steal books and treasures and other things he wants for his collection. I heard them talking about it," she explained, "when I was hiding inside the tower."

Master Brambleburn rested his chin on the steeple of his plump fingers. "Consorting with goblins. This is a serious accusation indeed, young friends. A matter to put before the entire Council, wouldn't you agree, Alderrod? He's no longer part of our circle, of course—"

"And yet, are we not responsible?"

"He studied here—"

"He was one of us—"

"Perhaps it was wrong to send him away—"

"But goblins, oh dear—"

"And *stealing* books—"

"Ladies and gentlemen," Alderrod cut through the talk, "inquiries shall be made. The ball, the runes, the stone, the bones—all must be considered at once."

Sneezle cleared his throat. "Master, sir, while you're finding out about Malagan, could you ask the balls and the bones and all that stuff about little Chick? She might have a mother somewhere, you see. We don't know where she belongs."

Alderrod smiled at the boy. "Of course. Tamaryst, would you be so kind as to go and fetch your crystal ball? This, at least, is a mystery that the ball should solve quite easily. Somewhere in Old Oak Wood a faery clan must be missing a child."

The sorceress rose and left the room; when she returned, she carried a box. Inside, on a bed of silk, was a heavy globe of clouded crystal.

Sneezle sat forward curiously as she placed the globe on a tall brass stand. She took off her thick spectacles, touched the globe with her fingertips, then murmured a rhyming spell as she stared into the crystal's depths.

"Hmmmmm," said Mistress Tamaryst.

"How odd . . ."

"How strange . . ."

"How very peculiar," the sorcerers all spoke at once.

Sneezle frowned. He couldn't see anything in the crystal globe at all.

"What is it?" asked Twig.

"All I can see is snow," Tamaryst replied, frowning. "I ask for information on the child, and I get a weather report!"

"That's not *our* weather," said a sorcerer in gray.

"It's the weather we *should* be having," said another.

Sneezle squinted, then crossed his eyes. He still could not see anything.

"Most perplexing," said Alderrod, standing behind Mistress Tamaryst. "May I, Tama?" he asked politely, then took her place at the crystal ball. "Hmmmm. A winter storm covering the moor. Snow

falling thick and furious. But what has this to do with a baby faery? Come, come now, ball. Don't be obscure. Tell us: *Where does she belong?*"

"The ball doesn't seem to want to answer," said Tamaryst, sounding rather put out.

"But perhaps it does," mused Alderrod. "Perhaps the weather and the child are related. But how?" He began to pace again, around and around the library table—a familiar route, it would seem, judging by the worn path in the rug. "Remember the letter we received just yesterday? The king wants to know why winter hasn't come—yet when we ask the ball his question, too, we get no answer."

"My ball has been temperamental of late," said Mistress Tamaryst with a sigh. "Or maybe it's my spells that no longer work, along with my eyesight."

Brambleburn put a hand on her shoulder. "The runes give the same answers, my dear. Or rather, they give the same non-answers. You mustn't blame yourself."

Alderrod continued thinking out loud. "His Majesty is right, of course, when he says that winter is long overdue. The trees are tired. They need to drop their leaves, sleep, and gather strength for spring. The hibernating faeries are still awake—overtired and quarrelsome. The forest soil needs snowmelt. The fish in the rivers need to dream their winter dreams. Last night I decided that one of us must go seek out the elementals."

A buzz of talk broke out in the room.

The First-staff raised his voice and continued. "Yes, I know, ladies and gentlemen, that few of us have been outside this library in many years. We've grown old here among our books while the clock ticks on and the world passes by. Not one of us here relishes the thought of a journey through the wildwood. . . ."

"It's just that my studies . . ." one sorcerer began.

"And with my bad back . . ." another fretted.

"But have no fears," said Alderrod, smiling behind his long white beard. "For we have a hero in our midst, the rescuer of the queen's Midsummer crown, and perhaps we can persuade our resourceful young friend to help with this task, too."

Sneezle's long brown ears perked up. "How did you know about the crown?"

"From the guardian of the Tree Oracle," answered Master Alderrod. "He's a member of our Council—somewhat unpleasant but an excellent scholar."

Twig leaned forward and spoke up then. "Just what exactly do you want Sneezle to do?"

"Merely to go find Lady Winter and deliver a message from us, my dear." Alderrod's manner was reassuring, but Twig still had some questions.

"Who is Lady Winter? Where does she live? How will we get there?" the marsh faery asked, pushing the tangled hair back from her eyes with a slender hand.

"*We?*" said Alderrod, raising an eyebrow.

"Of course. Where Sneezle goes, I go, too."

The chief librarian spoke up. "Ah yes! The 'Hero's Companion.' You remember, Alderrod. An important part of the quest motif in traditional heroic elfin lore. You'll have to send the girl as well to authenticate the journey."

Sneezle had no idea what they were talking about, but he cast a grateful look at Twig. There was just one thing that worried him, though. "You don't want to send us west, do you?"

"West? Why no," said the Master of Maps. "The winter winds come from the north, so I would think you'd find Winter up there, among the pines."

Sneezle nodded, mollified. Lady Winter was an elemental, and he'd met elementals before. Last summer he'd met the Lord and Lady of the Wood, who ruled the elemental world as Oberon and Titania ruled the faeries of Old Oak Wood. These spirits of nature, however, were even more elusive than the borrowers. "How will we ever find Lady Winter?" he asked Master Alderrod.

"Ah," the tall sorcerer replied, "I have already devised a plan. I've found an intriguing spell in volume 803 of *The Alchemists Annual*. Placed on your ship, it will cause the vessel to find the nearest winter storm."

Sneezle and Twig considered this. It sounded like a simple plan. But Twig had just one question more: "What if those goblins come looking for us?"

Tamaryst frowned at Alderrod. "It's possible that they will, you know. Malagan is very proud. This boy has bested him by stealing the child from his possession. He's going to be very angry, and the children could be in danger."

Alderrod paced before the hearth. "Yes," he

conceded. "Tama, you're right. The children had better stay here, where goblins would surely never dare to come. One of us must make the journey. We'll draw straws for it. Stin, fetch the broom!"

"No, no, wait," cried Sneezle. "Goblins *hate* the cold, don't they? They hibernate when winter comes. So the closer we get to Lady Winter, the safer we'll be—isn't that right?"

"Perfectly well reasoned," said Master Beezwottle.

"A sound deduction," said Brambleburn.

"But please," Sneezle added, "can the baby stay here? She needs protection most of all. And maybe in all these books you can discover what kind of faery she is. And if you can't, when we come back we'll take her to Queen Titania."

The scholars agreed to keep the child, and final details were soon settled. Provisions were packed: sausages, fur coats, Beezwottle's map of Old Oak Wood. Alderrod composed a letter on the finest parchment the college could produce asking Winter to please return to the forest at her earliest convenience.

Then all of the sorcerers of the Council—as well as the assistant sorcerers, apprentices, and library staff—gathered on the green to bid the two young travelers farewell. A river meandered through the grounds, dividing the lawns from the herb gardens, and here the shoe bobbed in the water, looking more like a ship than ever. Sneezle knelt down and explained to Chick that she must stay with the scholars for a while. He hugged her very close, and she rubbed her face against his furry cheek.

Once again, the ship had a mind of its own—this time under Alderrod's spell, which filled its sail with a wind instructed to take the two companions north. The slate shingles of the library roof soon disappeared behind the trees as the shoe cut through deep water, raising plumes of spray on either side.

This was more like it, Sneezle thought, breathing the scents of water and earth. He didn't much care for flying ships, but sailing ships were a different matter. The boy stood in the prow of the shoe with his long brown ears streaming out behind, watching the trees slide by and the sunlight

sparkle on the water's surface.

He waved to all the faeries they passed—nixies sporting in the water's foam; otterish creatures on the riverbank; graceful sylphs flying overhead, flashing silver against the clouds. Upriver, he spied kelpies at play. Shaped like big black water-horses, they dove and then emerged in human shape, minnows in their fists. Here, carried by water and wind, the goblin lands seemed far behind. For the first time since he spotted the soldiers by the weir, he began to smile.

Sneezle turned to share these sights with Twig—but she was sitting in the heel, her nose buried in a little red book, ignoring the river journey.

"What's that?" he asked, coming over to sit beside her.

"I found it in Malagan's tower. It's a book of spells, like recipes." She held it out to him.

"Spells for cooking?" He pushed the book away. It smelled of mice and mold.

"No, silly, recipes for making magic," Twig explained.

He scratched his pelt. He had picked up a flea or two in Malagan's filthy tower. "What do you want to read that for? You're a faery. You're magic already."

"I think it's interesting, that's all, to learn what magic can really do. You could change a leaf into a coin, for instance."

He wrinkled his nose. "Why would you want to do that?"

"I don't know," she replied, annoyed. "It's just that you *could* if you wanted to. You could even change your own shape, Sneezle. You could turn into a bunny, say, and join the other team for Chase the Rabbit. Or a hedgehog or a piskie. Or even a Big Person."

"But why would you want to do any of that?" Sneezle asked. "Why wouldn't you want to be yourself?"

"A handmaiden?" said Twig quietly. "Just sit around looking pretty all day?" She closed the book, tucked it into her pocket, and sighed

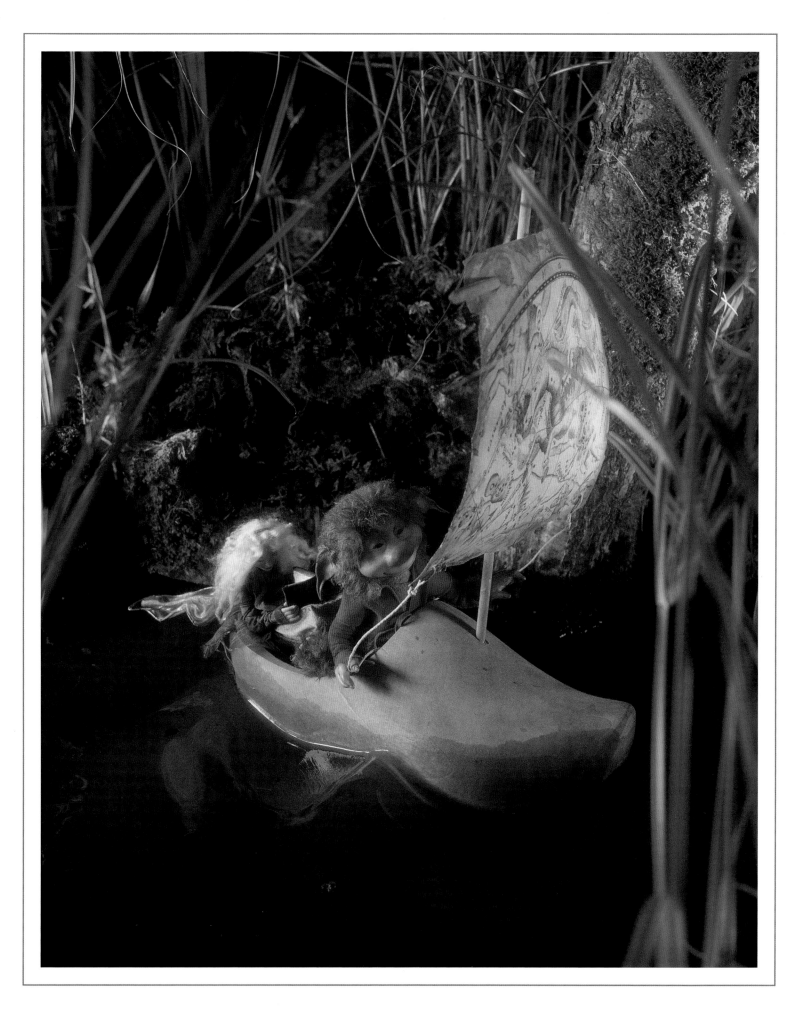

deeply. "Oh, never mind."

At that moment, the shoe rocked violently. What on earth was going on? Sneezle stumbled to the prow of the shoe, peering over the side.

The ship was surrounded by a kelpie pack, all wearing their slim green man-shapes now and grinning at him with teeth like ivory, sharpened to little points. They were pushing and pulling, pulling and pushing the shoe, laughing uproariously.

"Y-yes, yes, that's very funny," Sneezle stuttered, forcing out a wavering smile. "But put us down now, if you please. . . . Just go away, boys. . . . Let us be. . . ."

The kelpies thought this was even funnier. They turned back into horses again and heaved against the side of the ship, sending it rolling, causing a wave of water to fill the shoe.

Sneezle grabbed a bucket and began to bail.

Twig cried, "It won't do any good! We're sinking!"

"I can't swim!" Sneezle yelled at her.

"I can't either! We'll have to fly!" But her wings were sagging—waterlogged and heavy as wet draperies. She flapped them, leapt into the air, and landed in the river.

Sneezle made a lunge for the mast as the paper sail ripped and the shoe sank even lower. Twig floated by and grabbed the tails of his coat, fighting against the current.

"Just hold on," Sneezle sputtered, clinging to the mast. "Those kelpies are only having fun. Hold on tight, and they'll be back. They're not going to let us drown."

"Don't hold your breath," said a husky little voice. "Them blasted kelpies is nothin' but trouble."

Sneezle turned toward the voice and found an odd little faery paddling close by.

"I'll swim you ashore," said the squinty-looking fellow. "My uncle there is helping the lady."

Another faery had taken hold of Twig and was paddling to the riverbank, so Sneezle let go of the sinking mast and clung to the fellow's neck. When they reached the bank, he climbed up into the reeds, coughing and sputtering; then he took off his sodden coat and shook his wet pelt like a dog.

His rescuer stuck out a knotty little hand. "Pedar Rootmuster, at your service. That yonder is my uncle Wirt and he's a Rootmuster, too."

"Rootmuster?" Sneezle exclaimed, pumping his hand. "Why, I'm related to the Rootmuster clan! I'm a Rootmuster Rowanberry Boggs from Greenmoss Glen, down in the southern woods. Sneezle's the name. And I thank you very much, Pedar Rootmuster, for saving my life!"

"Ah, weren't nothin'," Pedar said modestly. "Just kelpies up to their usual tricks. We're always fishing folk out of there—you're not the first and you won't be the last. Good to meet a relative, though."

"I'm much obliged all the same," said Sneezle. "Where is my friend? Is she all right?"

"Right as rain. Follow me, cousin. Uncle Wirt took her back to the village."

"The *village?*" said Sneezle, his eyes growing wide.

"That's right." Pedar gave him a crooked smile. "That yonder is Old Root Village—oldest root faery dwelling in Old Oak Wood. You've heard of it?"

"*All* tree faeries know of Old Root Village!" Sneezle exclaimed. "I've always wanted to see it one day."

"And now you will," Pedar replied, "so I reckon them kelpies did you some good. Kelpie tricks are often like that—bad and good all at the same time. Only lately those fishboys have mostly been bad— you're the third set of travelers we've rescued this week. Uncle Wirt says kelpies ain't been this riled up in years."

"Maybe it's the weather," Sneezle suggested. "Could be so," Pedar agreed. "The river is usually iced over by now, with them kelpies all fast asleep at the bottom. Our old folk say they've never seen kelpies 'round here after Midwinter's Eve."

Pedar led his young cousin to a path running straight through the tall river reeds, then the two of them scaled the roots of an oak to a sharp rise of land above. When they reached the top, Sneezle gasped with surprise at the vast faery village spread before him, built into the roots and limbs of a thick stand of sycamore trees. Dwellings were perched one on top of another, constructed of wood, willow, and bark, thatched with reeds or shingled with acorn shells grown green with moss. Everywhere Sneezle looked were tree root faeries— not plump and furry ones (like his own Boggs clan in the southern woods), but homely creatures with

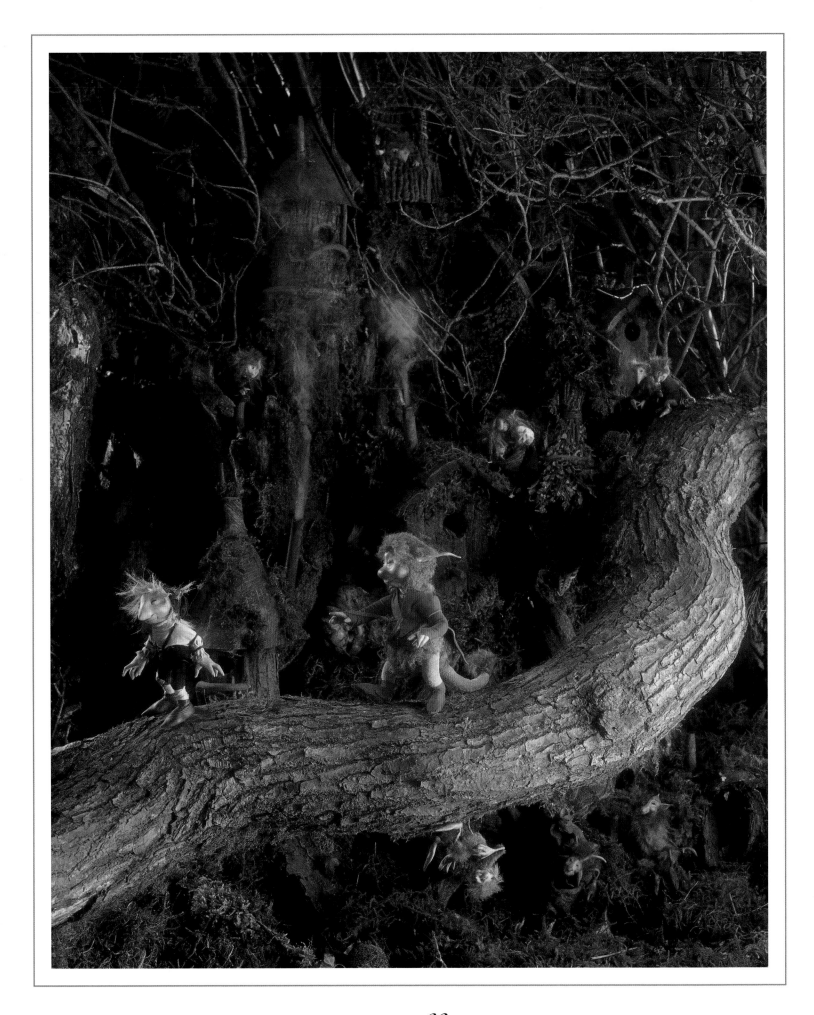

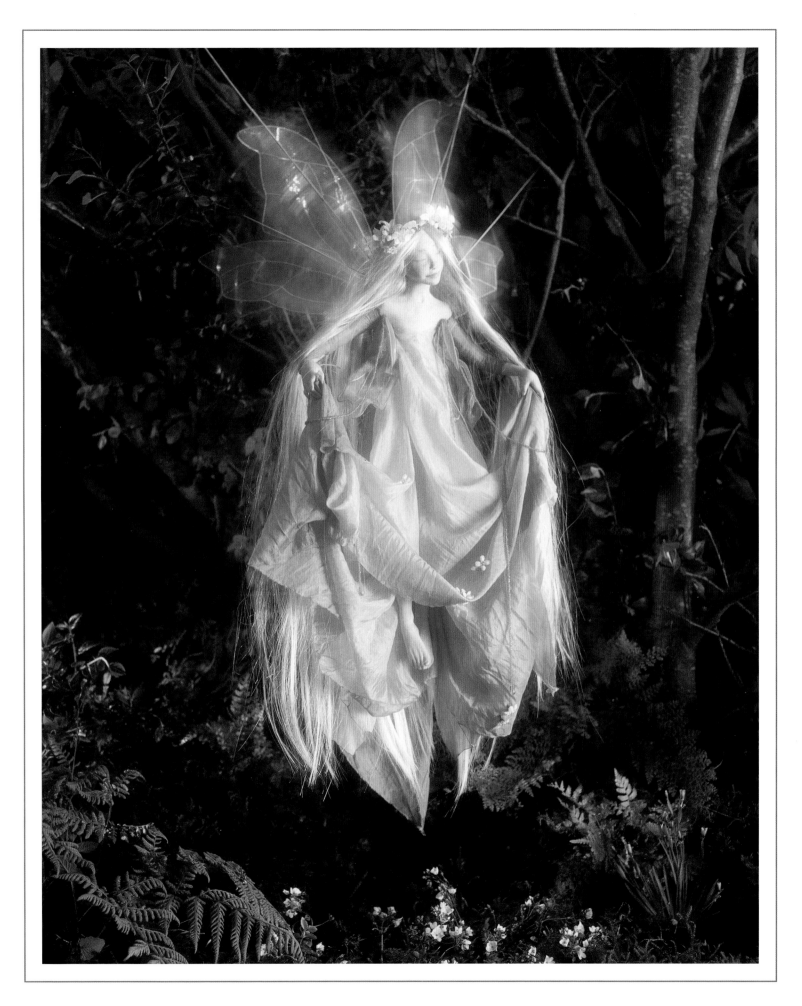

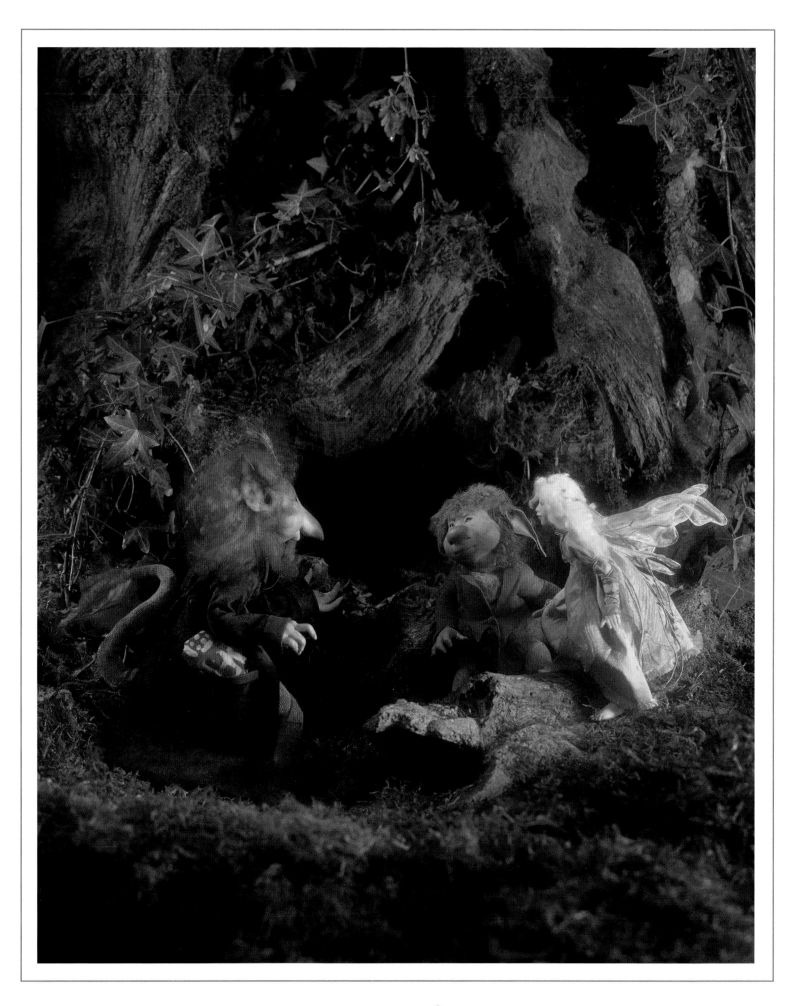

gave her fingers a kiss. "Reynard at your service. Perhaps I may be of some assistance?"

"That's k-k-kind of you," Sneezle stuttered out, feeling clumsy, grubby, and ill at ease. Twig was smiling at the man. She gave him a formal curtsy.

"A lady of the court, I see! Most excellent!" said the gentleman. "One rarely meets such rarefied company in this part of the forest."

"We're on a quest," Twig confided to him.

"A quest? How exciting," Reynard murmured. "Why don't you come to supper, children, and tell me all about it? I live alone up here, you see, and news comes slow to the northern woods. I long for civilized company and proper conversation."

"Sorry, can't stop now," said Sneezle.

"Yes, we'd love to come," gushed Twig.

"Except that we've really got to be hurrying on," said Sneezle anxiously.

"*After* a rest," insisted Twig, staring up at the handsome stranger.

Reynard put his arm through Twig's. "Come, tell me all the news, my dear. What are they wearing at court these days? Your own frock is so lovely that it must be the very latest fashion. And who has won the winter games? You've been to the Midwinter feast, have you? Come sup with me, fair lady, and tell me everything, I insist."

Sneezle took Twig's other arm. "We already have supper plans."

"Don't be so silly!" Twig hissed at Sneezle.

"*You're* being silly!" Sneezle hissed right back. "We're on a quest!"

"Our quest can wait! Besides, I thought you *liked* to eat."

"Ah, a young gourmet," said Reynard, turning to smile at the boy. "My cooking is excellent, young sir, and my wine cellar will astonish you. Supper tonight will be *delicious,*" he promised, his dark eyes gleaming.

Twig turned to Sneezle. "You can come along or you can wait right here, but *I'm* going."

He scowled at her and said, "If you're going, Twig, then I'm going, too."

"Delightful. Follow me, my friends," said Reynard with a little bow. "My humble home lies just ahead, and it's nearly supper time."

He led them to a hollow among the trees, where roots and tangled vines had framed the doorway of a den carved into a bank of earth.

Approaching the door, Sneezle caught a strange sound. He paused and cocked a single ear. "Do you hear that?" the boy whispered to Twig. He cocked the other ear, and there it was again— a barking sound, almost like soft laughter. It came from the dark ahead . . . where Reynard had said that he lived alone.

"Don't go in!" Sneezle cried, pulling his friend away from the stranger's door, away from whatever lay, laughing and waiting, in that treacherous dark.

"Sneezle, where are we going?" Twig gasped out breathlessly as the two of them fled, Reynard crashing heavily through the underbrush behind them.

"Away! Away from those fox faeries!" he answered. "Don't you hear them barking now?"

Deep laughter rumbled through the woods, joined by a high, sharp yelping sound; and Twig gasped as she scrambled through the forest after Sneezle. Fox faeries! What were *they* doing here in the northern hills of Old Oak Wood? Oberon had banished them all to the goblin lands years before.

The children ran through brambles and briars, splashed through a stream, and ran up a steep hill on rabbit trails hidden deep within rust-colored plumes of bracken. The sound of laughter followed them, grew fainter, fainter, then died out. They slowed and finally stopped, and realized they were now thoroughly lost.

Sneezle sniffed the air with his sensitive nose. He could no longer smell the river, just oak trees, ivy, and damp earth. And a delicate whiff of roses.

*Turn away from the barking fox, cross running water, and follow your nose. . . .*

Sniffing the air, he took Twig's hand and followed the scent of flowers.

At the top of the rise, a stand of stunted, gnarled oaks stood bent together like guardians of the hillside, watching the travelers pass beneath them. The smell of roses grew stronger here, leading them through the crooked trees until they reached a small arched door set into a wall of stone. The door was overgrown with weeds. It took some work to open it, but soon Sneezle and Twig had pulled it wide enough to slip through.

Inside, they found a circle of green grass surrounded by flower beds, enclosed by tall stone walls half buried in roses, pink and white. Outside, the air had turned to dusk and grew cold now as night came on, but inside, sunlight poured its warmth onto the secret garden. Hollyhocks waved in a gentle breeze, bees buzzed over lavender, and lilies opened pale white throats to the blue of a summer sky.

At the far end of the garden sat a woman dressed in lilac and gold, playing a game of chess against a small piskie with a hedgehog's face. The woman was just as beautiful as her garden, her hair the color of flame, her dress richly embroidered with bees and birds and summer flowers. She looked up at the children's approach and smiled at them without surprise. She motioned for them to come forward, then continued with the game.

"Lady," said Sneezle, kneeling in the grass, "your younger sister sent us here."

"I know," she told him, picking up her pawn and moving it one space, "for otherwise, you'd never have found your way into my garden."

The piskie frowned, studying the board. The bees hummed in the air above. Eventually the piskie moved and captured the lady's bishop.

The game went on. The woman seemed almost to forget their presence there, concentrating on her game as the garden drowsed around her. A fountain bubbled somewhere beneath the roses. They could hear its soft music, along with the wind in the flowers and the gentle click of the carved chess pieces. Time passed. The piskie took a pawn, a rook. The lady lifted her knight. Overhead, a crow cried out and the woman looked up at them.

"You're patient and you're courteous," she said. "These are strengths, so treasure them. My sister was right to send you to me. Tell me what it is you seek."

"We seek Winter," Sneezle replied. "Please, can you tell us where she is?"

"No, alas," the woman said, "but perhaps my elder sister can."

"But where do we find your sister?" asked Twig.

"Where you least expect her, of course," said the woman. She placed the knight back on the board. "Check," she said with a little smile. And with that word, the lady and her garden disappeared.

Sneezle blinked and looked around him. He was kneeling on the cold hillside, Twig beside him,

the old trees turned away now, faces hidden.

Climbing wearily to his feet, he said, "I still smell roses, Twig."

She pointed to his buttonhole, where he found a small white bloom.

The flower glowed. It cast a path of light through the twisted, ancient trees, leading them safely down the hill, back to the stream below. There the light began to dim, and the rose blossom to dry and crumble, as though it could not last this far away from the secret garden.

The rose faded entirely, and now the night seemed very dark, with only the barest sliver of golden moon poised overhead. They ate their supper by the stream, made two beds out of leaves and moss, and fell into deep and dreamless sleep as an owl hooted nearby.

*　*　*

Sneezle woke just before the dawn and sniffed the air. It smelled like—tea? He found Twig by the stream bank with a blue teapot beside her.

"This was in the bundle from the first sister," she told him, grinning. She handed him a cup of tea.

"It's hot!" he exclaimed.

"It's magic!"

They breakfasted on toast and jam from the bundle's seemingly endless supply. (When Sneezle asked for cake, the stubborn bundle remained quite empty.) The early morning air was cold, and mist clung to the stream below. The rising sun was still barely a glimmer through the willow thicket.

"What do we do now?" he asked, brushing toast crumbs off his pelt. "We don't know how to find Winter or the third sister or the way home."

Twig sat down on the flat of a mossy rock above a tranquil pool; she rested her chin on one bent knee and looked down at the water. Fish swam in its depths, small shadow shapes against the bottom stones. She said, "We need to find the third sister. It's our only clue."

"It's not much of a clue," Sneezle grumbled.

The marsh faery frowned. "All right, let's think. She'll be where we expect her least. But where is that, do you suppose? In a borrower's nest? In Malagan's tower? In the library? Back home at

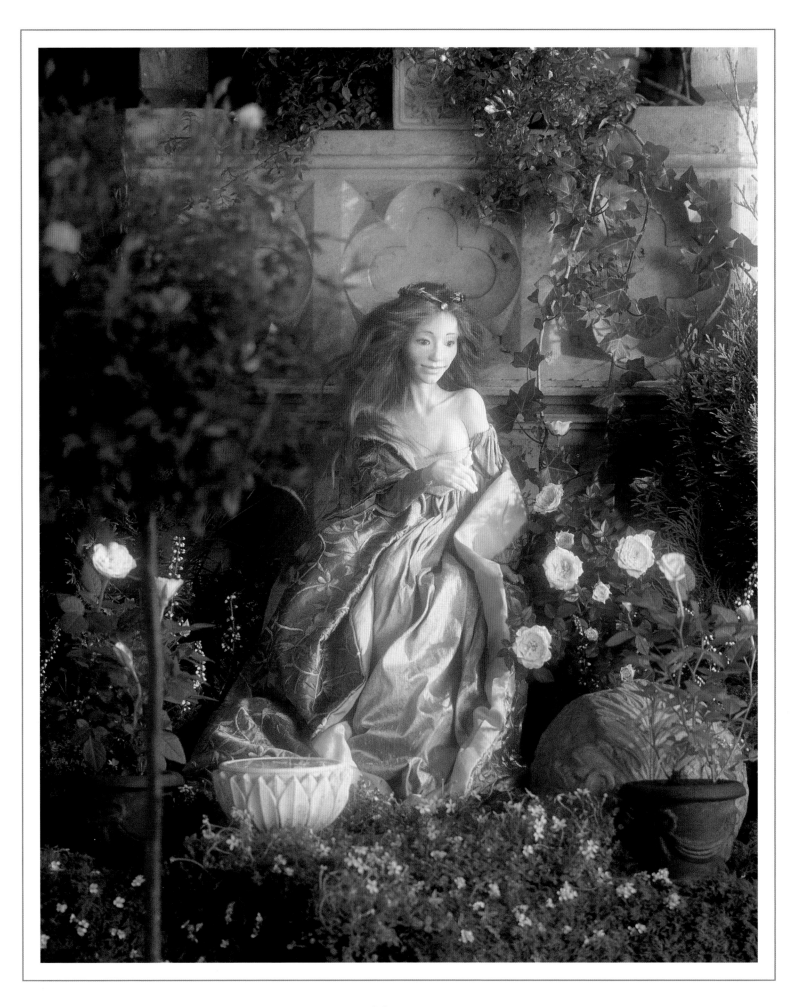

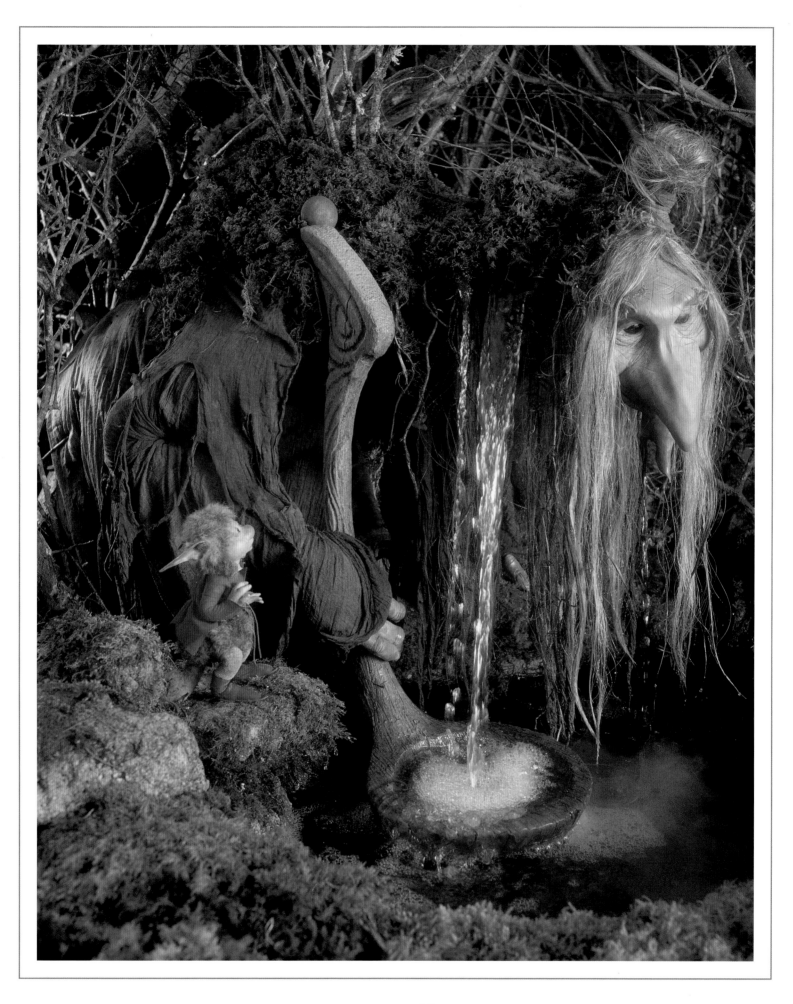

court? We don't expect her in any of those places, so maybe that's where the third sister is . . . except if she's there, then we're expecting it now. . . . Oh, this is making my head hurt!"

Sneezle threw pebbles into the pool, ears drooping around his face. "Well, I know where she won't be," he said, discouraged, "and that's wher-ever *we* are."

Twig looked up. "You're right, Sneezle! *This* is where we expect her least!" She jumped to her feet and peered around.

There was nothing but rock and water.

"Never mind." Twig was disappointed.

Sneezle threw another stone into the pool, watching lazy ripples swirl like soup stirred in a pot. Then the water slowed, stilled, and the young root faery caught his breath. The woman *was* there. *There,* her face reflected on the surface of the pool. He lifted his eyes to the rocks up above, and where granite and willow had stood was now a hunched, wizened brown woman, formed of earth and roots and reeds, water flowing through her silver hair to the stream below.

"Tw-i-ig," Sneezle tried to say. It came out as a mere whisper, a mouse's squeak.

"Oh my stars and whiskers," Twig breathed, staring at the old, old woman.

"Childrennnnn." The old one spoke in a voice of wind, water, and flame, a voice of granite from the bowels of the earth. "Welcome . . ." she sighed, her voice no louder than the rustling leaves. "You have come a long way. . . ."

"Yes, green-mother," said Sneezle, "we've come a long way. We're tired and we're lost. Can you help us, please? We seek Lady Winter. Do *you* know where she is?"

The old crone moved her head, and the very earth seemed to move and shift underfoot. "Where I am . . ." she said slowly, "winter . . . is never . . . far . . . behind. . . ."

The old one's eyes began to close.

"Wait, wait, green-mother, please!" he cried. "I'm not a sorcerer—I'm just a tree root faery and I don't understand these riddles."

One eye opened and pinned the child with a gaze both warm and terrifying. This was not a maundering old woman; this was the power of the earth itself. The old one spoke one final time, and Sneezle strained to make out her words. "Beyond,"

she breathed.

"Beyond?" he repeated.

"Beyond . . . beyond the wooddddd. . . ."

The eyes closed then, the face hardened, and the wrinkles turned to seams of stone. The crone was gone; there was only rock, water, wind, and autumn leaves drifting to the stony ground.

The leaves were falling.

*The leaves were falling!*

The children snatched up armfuls of brown leaves, laughing, their eyes shining. Autumn was at its end here at long last. Winter was close.

They followed the stream, blazing a trail through boulders, tree roots, nixie dams—the air growing steadily colder around them the farther they went north. Asking each of the faeries they passed to point the way to the edge of the wood, they hurried on, knowing that they traveled in the right direction at last. Neither Twig nor Sneezle had ever jour-neyed outside the forest before. The thought of it was frightening and exciting in equal measure.

By morning's end, the trees began to thin. Large patches of sky were visible, blue shading to a steely, wintry gray on the far horizon. The land up here was stony and bleak compared to the deep green southern woods, and populated by solitary brownies with faces as wrinkled as walnuts. The travelers crossed the leafless hazel copse that marked the northern tip of the wood, and at its end they finally reached the last oaks of the forest.

Old Oak Wood was bound by a low stone wall buried in thick ivy, and beyond the crumbling wall was the realm Sneezle knew only as the Beyond. Humans lived in the Beyond, and other faeries lived there, too, in other faery courts in distant fields and fens and forests. Open moorland stretched before them—empty hills rolling on and on, crowned with massive piles of boulders in strange, fantastic shapes. The sky above was a sheet of gray. Snowflakes flurried in the air. Ice and snow covered the land as far as their eyes could see.

"Sneezle, look," breathed Twig. "I never knew it would be so beautiful."

Sneezle agreed, and yet the sight before them also frightened him—for the snow came precisely

to the boundary wall and not one inch within. King Oberon had been right. This weather was *not* natural. Outside, white snow encased the world; inside the wall bright sunlight fell, dappling the autumn grass as thick and gold as honey.

"I wonder why Winter doesn't want to come into our woods," said Twig.

Sneezle stared at the wall, alarmed. "Maybe Winter *can't* come in."

Twig turned to him, biting her lip. "What could keep an *elemental* out?"

"The Big People?"

"But *why?*" she asked.

He shrugged. It didn't make much sense. Yet who besides humans would be so careless as to stop the seasons? The lives of the forest faeries had always been tied to the wheel of nature's cycles. Who would dare to meddle with the weather if not the Big People?

"Twig, look there." He pointed to a line of footprints in the snow, leading back and forth across the hills to a distant tor.

"Big People?" asked Twig. "They look too big and fat for faery feet."

He shook his head. "Too small for humans. What else could it be?"

"Goblins." Twig spat out the word. "They're just the right size for goblin boots."

"Maybe," Sneezle said, worried, "but goblins can't abide cold and snow."

"And fox faeries don't live up north, and kelpies sleep this time of year. Don't you see?" Twig scowled. "Everything is changing with the weather." She peered down at the footprints. They led right over the boundary wall, turning to mud prints in the warmer climate of the forest. "Something's gone into the woods and it hasn't come back out again. I say those are goblin prints." She picked up a good stout stick.

Sneezle did the same as Twig, and put a finger to his lips. Something moved in the woods nearby, crashing through the undergrowth.

The two companions ducked into the brush, creeping quietly toward the sound, Sneezle leading the way through feathery ferns and golden bracken. He raised his stick, parted the ferns, stepped forward—and then yelped out loud. The biggest, furriest faery he'd ever seen was staring back at him.

Sheepishly, the boy lowered his stick, his round cheeks flushing red. Before he could apologize, the furry stranger beat him to it.

"Oh dear, oh dear, I'm ever so sorry—oh no, I apologize, I'm abashed, I'm chagrined, I'm mortified," the faery rattled on, struggling with the many baskets he carried as fruit and mushrooms tumbled to the ground. "Not my forest, I know, I know, shouldn't be here—dreadfully sorry, I do apologize, feel just awful—gracious me, oh dear, oh dear—meant no harm of course, scavenging, finding food for the little ones—so sorry, my sincere apologies—I'll just be going—please forgive me, ever so sorry. . . ."

The faery lumbered over to the wall, spilling fruit behind him.

"Wait!" cried Sneezle. "Wait! It's all right! Take all the berries and stuff you want! Wait! We just want to talk to you!"

The furry stranger stopped and hung his head. "Oh dear, you're ever so kind. I'm sure I don't deserve it, oh no indeed."

"Where do you come from?" Twig asked him, eyeing the creature's thick winter coat.

"Just a poor plain little faery court, out there. Beneath old Vixen Tor. You won't have heard of it, I'm sure," the big fellow said mournfully.

"Is Winter there?" Twig asked.

"Winter is *everywhere*," he said, "but here. Worst weather we've seen in years and years. She's terribly upset."

Twig exchanged a look with Sneezle. She put her hand on the furry faery's arm. "My friend and I are looking for Lady Winter. Can you tell us where she is?"

"And why she's so upset?" asked Sneezle, picking up the tumbled baskets.

The faery shook his head sadly. "Oh dear, I'm afraid you've missed her now—if only you'd come yesterday. She just keeps circling 'round and 'round your forest to look for some way in. I tried to help, I did, I tried. I listened to her tell her tale and oh, how my heart bleeds for her, but what good is a clumsy oaf like me? No good at all."

Sneezle and Twig exchanged another look. "Why can't Winter get in?" asked Twig.

"On account of some kind of spell. Such a terrible thing." The faery sighed.

"What spell?" asked Twig.

"I really don't know." His long ears drooped with his distress. "And her poor child. Poor little mite. Oh bless my soul, how I do worry."

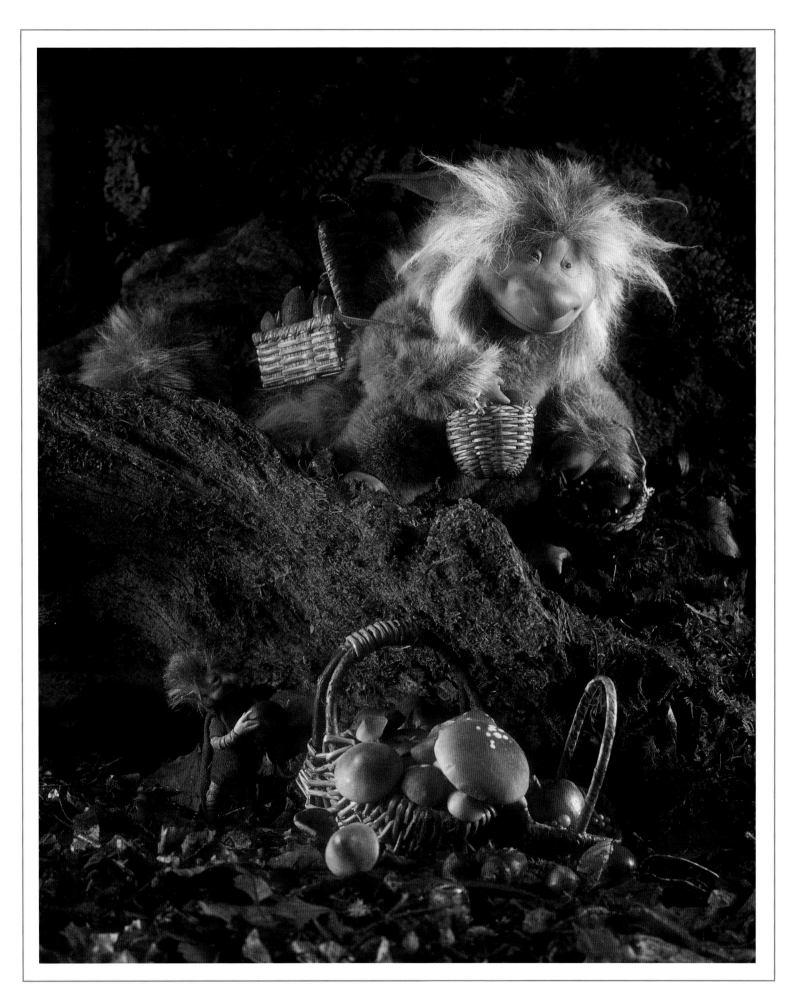

Sneezle's own brown ears perked up. What was this about a child?

Twig took the big fellow by the hand. "Please, mister—"

"Jorje. My name is Jorje," he told her with a sorrowful smile.

"Please, Jorje, my friend and I don't understand. What child are you talking about?"

"A *missing* child?" asked Sneezle eagerly. Could it be Chick?

Jorje nodded. "Lady Winter's child. The baby born from a golden egg. The one who'll grow to be Lady Spring next year. If she is found. But some old borrower snatched the egg and Winter thinks it's in your woods and now she can't get in because there's a spell that is keeping her out."

"Oh, Jorje, Jorje, I could kiss you," cried Twig. "You've told us just what we needed to know."

The big fellow backed up a step, his nose turning red as he blushed.

"So Winter may be Chick's mother," said Sneezle. "We have to go tell the Council at once. They have to break the spell that's keeping Winter out of the forest." Twig's earlier words came back to him then. *What could keep an elemental out?* Only magic of the most powerful kind. He shivered, not from the cold.

Twig turned to Jorje. "Please, Jorje, can you give a message to Winter if she comes this way? Tell her that we've gone back to ask for help from the Council of Sorcerers. And that we may know where her child is. Will you do that for us?"

"Of course, of course," said the big faery. He turned, leaving his fruit behind.

"Don't forget your baskets, Jorje," said Sneezle. "Please take the food you gathered. You're welcome to it. Think of it as a gift from our court to yours."

"Why, gracious me, I couldn't, oh no, I couldn't— oh well, I suppose I could, just this once. Oh my stars and heavens, you're both so very kind. . . ."

They packed his baskets up again and helped him clamber over the wall, while Jorje continued apologizing until he'd lumbered out of sight.

Twig turned away from the ice and snow, and sighed. "We've got a long way back."

"There's no time to be lost," Sneezle pointed out, "so we'd better get going."

"Flying is fastest," Twig reminded him.

"Then *you* should fly," Sneezle agreed.

"I'll carry you—"

"Oh no," Sneezle interrupted. "I'm staying on the ground."

"Then so am I," his friend declared. "I'm not leaving you alone in the forest, not with goblins on the loose and fox faeries and kelpies and goodness only knows what else besides."

Sneezle swallowed. He didn't want to be left behind, if the truth be told. And yet he couldn't bear to think of Winter separated from her child. "Go on, fly ahead of me. I'll manage just fine," he told her stoutly.

"I have a better idea," she said, producing a little red book.

Sneezle hadn't known she'd saved her magic book when the wooden shoe sank. It was water-logged and stained, but parts of it were still readable. Twig flipped through the pages purposefully. "What are you looking for?" he asked.

"A spell . . . a spell . . . I know the one. . . . Ah, there it is!" She pointed at it.

He could barely read the muddy page. "What's that?" he asked suspiciously.

Twig gave her friend a superior smile, pleased with her own cleverness. "I shall turn us into horses," she said, "and we'll gallop through the forest!"

"Oh no," said Sneezle, shaking his head, "not me. I'm staying the way I am."

Twig wrinkled her nose. "All right, then. I'll be the horse, and I'll carry you."

She put the book on the ground opened to the page, while Sneezle hovered anxiously.

"Oh dear, I don't think this is such a good idea. . . ."

"You're starting to sound like Jorje!" scolded Twig. "Hand me that stick behind you, and hush. I need to concentrate."

She examined the stick. Rowan wood, excellent for spells, according to the book. She waved it once, testing its weight, and then lifted her wand up high. *"Barryl rye apozum,"* she intoned, reading the elfin script. *"Barryl maheen o fazdatirspit. Mikwa, mikum, mikbostaddle bottim y tinder marzminnow idjit!"*

Thunder clapped and Sneezle yelped. Twig gasped and let go of her stick. She took a step like a sleepwalker, staring straight ahead of her, and then

she fainted. Sneezle ran to grab her . . . and clutched only fistfuls of air.

She had disappeared. No Twig. No horse. "Oh no," Sneezle moaned in deep alarm.

A little white mouse skittered over his boot. It was squeaking, chattering, staring up at him, its hands on its hips like Twig when she was angry. . . .

Earth and bones, it was her!

He grabbed the spell book and peered at the page, wiping mud away with his sleeve. It wasn't a spell for becoming a *horse*—it was a spell for becoming a *mouse*.

"All right, don't panic," he said to Twig.

She chattered at him in her squeaky mouse voice. He didn't know what she was saying, but he could tell she was far from pleased.

"We'll reverse the spell," he assured his friend. "Don't worry, I've done it before, remember? When Rianna turned that handmaiden into a mouse, I cut off her head and it broke the spell. I just need to find something sharp . . . don't fret . . . it's not going to hurt a bit. . . ."

But Twig was squealing and jumping up and down, shaking her little paw at him.

"All right, all right," he said, lifting his hands. "I understand. No cutting off heads. We'll think of something else."

The mouse pointed to the book, tapping her tiny foot.

"I'll look in the book," Sneezle agreed. He held the spell book warily and squinted at the fine print under the spell: *To reverse, reverse.* Stars above, how he hated riddles! "Does that mean I should read the spell backward?"

The mouse bobbed her head.

"But what if I get it wrong?" he asked her. "What if I only make it worse?"

The little white mouse shrugged hugely, as if to say: What could be worse than this?

He clutched the book and took a deep breath, then he felt a nip on his ankle. She'd bitten him! Ah, he realized, she was trying to remind him to pick up the rowan stick.

The stick was warm from the previous spell and tingled slightly under his fingers. Sneezle raised it with one hand, held the spell book with the other, then he began to puzzle out the backwards letters, reading slowly: *"Tijdi wonnimzram rednit y mittob elddatsobkim, mukim, awkim. Tipsritadzaf o neeham lyrrab!"*

This time there was no thunderclap, just an unimpressive, muffled *thump.* The mouse staggered, then slumped over. It disappeared in a puff of smoke. Then it reappeared, the size of Twig this time, and wearing Twig's dress.

Sneezle gulped and paged quickly through the book. There had to be another spell! Minnows, merrows, mermaids, mandrake roots . . . nothing about gigantic mice. But there *had* to be something. He flipped the pages frantically, starting to sweat.

"Sneezle, Sneezle, stop—it's all right!"

Twig!

She was getting her own shape back. Slowly the white mouse shape was fading, bit by bit, whisker by whisker. She had her faery body back now, her arms and her legs and her muddy white feet—but her hands were still two small paws. Her face was her own, and her mischievous eyes—but she still had a rodent's nose and two pink ears poking through her hair.

"It will go away," she assured him gravely, stuffing her tail under her skirt.

"Of course it will," he agreed warily.

She glared at him from behind her whiskers. "Don't you dare laugh at me," she warned.

"Of course I won't." Sneezle bit his lip.

From the trees came the sound of giggling. A flock of faeries perched in the branches, tiny maidens with gossamer wings, all tittering behind their hands. Twig shook her fist at the faery flock . . . and then she started giggling, too. The tiny maidens exploded in laughter, falling from the trees in merriment. And Sneezle's laughter was loudest of them all . . . except for Twig's.

"Cousins," Twig addressed the flying maidens when she could speak again, "my friend and I need to travel to the Royal Library just as quickly as we can."

"Easily done," said a delicate sprite draped on a pine tree's feathery branch. "We can carry the furry one between us while you fly ahead and lead the way."

"No flying," said Sneezle flatly, but Twig placed a paw on his small brown hand.

"For Chick," she said. "Her mother must be so worried about her, Sneezle."

He bowed his head. She was right, of course. "Okay, I'll do it," the root faery mumbled.

She squeezed his hand, her eyes shining at her friend's kind heart and courage.

Twig flapped her wings experimentally, glad to discover that they still worked, then raised herself through the trees rather clumsily, on account of her tail.

Giggling still, the faery maidens surrounded Sneezle, taking his arms. They lifted him gently from the ground, cooing like doves and patting his cheeks as they rose through the canopy of leaves and burst into the sky above.

✳ ✳ ✳

Far below, a solitary brownie stopped astonished in his tracks. First he saw what looked like a flying mouse—and then, even stranger than that, a tree root faery soared over the trees, his coattails flapping like wings.

Stin waited on the library steps, Barnacus yapping at his heels, as Sneezle, Twig, and the faery maidens descended from a cloudless sky. The bent old doorkeeper beamed at them. "Welcome back, Weasel Bear and Fig. The masters saw you coming in the crystal ball and said you'd be escorted."

Stin bowed to the leader of the faery flock, who perched on an old rainspout above, and held a basket out to her. "We thank you for your aid."

The basket held sweet honeycombs, small crocks of jam and flower pollen, and a slim bottle of honeysuckle nectar of an excellent vintage. The maidens were delighted with these gifts, flying in lazy loops above the lawn before they waved and headed home again.

"Now come along, children. What? Eh?" said Stin, clutching his ear trumpet as he led them up the steps and through the library's tall arched doorway. Inside, the sleepy atmosphere had been transformed during their absence. Doors slammed, steps clattered, voices drifted from rooms in all directions.

"WHAT IS ALL THIS?" Sneezle yelled to Stin.

"What, where's the little miss?" said Stin. "Why, she's right there!"

Chick was running down the hall as fast as her legs allowed. She flung herself at Sneezle, laughing. He lifted her up and twirled her around. The girl seemed to have grown again—she was heavier in Sneezle's arms as they followed the old doorkeeper down the hall to the First-staff's study.

Alderrod was waiting there, and Brambleburn, and Tamaryst, all of them even older and frailer looking than they'd been before.

"We've just come from the north," said Sneezle.

"Yes, we know," said Alderrod, "for we followed your quest in Tama's crystal ball. Welcome back, Sneezlewort and Twig. Have you brought us news of Winter?"

"Didn't you see that in the ball, too?" Sneezle asked the sorcerers, perplexed.

Alderrod sighed. "The ball is still not working properly, I fear. The farther away you went from us, the fainter your image grew, children, and when you left the boundary of the woods, the picture faded. There's some strange magic loose in Old Oak Wood, interfering with all of our spells."

"So tell us what you have learned," said Brambleburn impatiently.

"First, sit down," said Tamaryst. "You've come a long, long way."

Sneezle perched on a velvet chair, and then jumped up again to speak.

"It's snowing in the Beyond," he cried, "but there's no snow inside the wood! Someone has put a spell over our forest. Winter can't get in!"

"A spell?" repeated Tamaryst. The sorceress looked horrified. "What earthly power could stop the seasons' cycle in its tracks?"

Alderrod began to pace, stroking the length of his long white beard. "The same power that's stirring up the goblins and their kind." He turned to the children to explain, "We've had more trouble in the wood. Goblin sightings, fox faeries, a troop of red-caps on the loose. And irreplaceable books were stolen from the faery queen's own chambers."

"Malagan." Sneezle hissed the name.

"Yes, that's what I fear," said Alderrod.

"And I disagree," said Brambleburn. "Book theft, yes, that I can believe. But could a single sorcerer stop the wheel of the seasons? Preposterous!"

"Malagan could," said Tamaryst. "You've no idea how powerful he is."

"Powerful enough to meddle with the elementals?" the chief librarian scoffed.

"Yes, he is," said Tamaryst quietly.

"But *why?*" Master Brambleburn asked her.

"Because he thinks he can get away with it," Tamaryst told the librarian sadly, "just as he thought

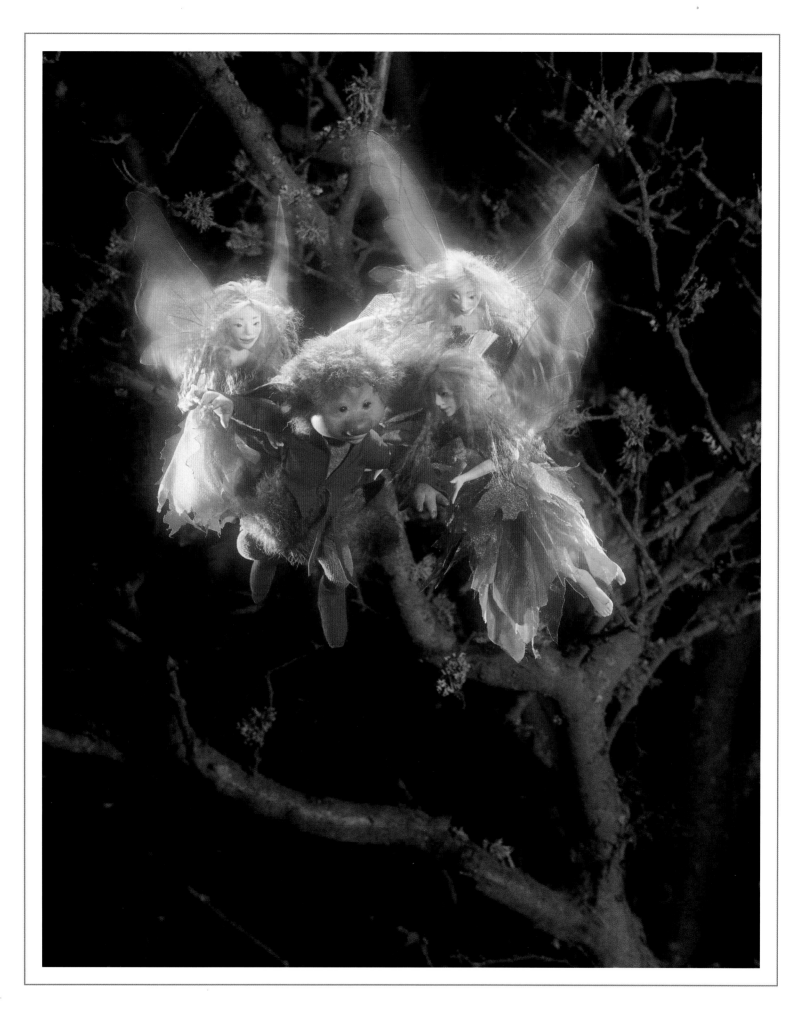

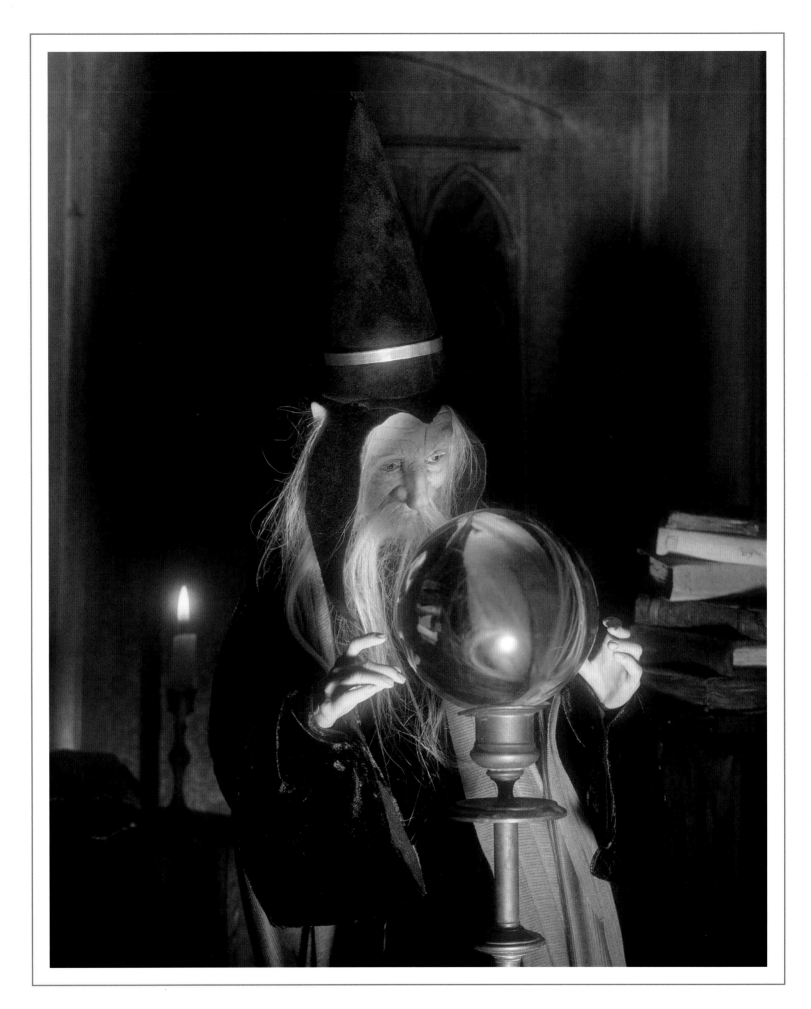

he could get away with faking that paper on elfin rhyming spells. He thinks that because he's cleverer than most, he can do anything to get what he wants."

"But that's not all we've learned," said Twig. "Poor Lady Winter has lost her child!"

"A child born from a golden egg," Sneezle explained to the sorcerers. "A borrower stole the egg, so we think the missing baby could be Chick."

"Chick, of course!" murmured Alderrod, while Tamaryst looked thunderstruck.

"No wonder I couldn't determine her faery clan," said Brambleburn.

"Winter has been circling the forest," said Twig, "trying to find her baby."

Alderrod paused behind his desk, leaning upon his long, thin hands. "We must break the spell that's keeping Winter out of Old Oak Wood."

"Of course, but how?" asked Tamaryst, pacing the rug like Alderrod. "Only the one who made the spell can break it up again, unless—" Her voice and pacing faltered, and the room went suddenly silent.

"Unless what?" Sneezle spoke up.

"Unless," said Brambleburn slowly, "the one who made the spell is challenged by the Royal Council." He turned and looked up at Alderrod. "*That's* why you've called the others here—not to talk about stolen books! You're gathering the Council and you mean to *challenge* him!"

Alderrod inclined his head. "Yes, you are quite right," he said. "I've called all thirteen sorcerers here, for I feared that it might come to this."

"So, First-staff," said Tamaryst, so softly she was almost whispering, "do we summon Malagan and present the Council Circle's Challenge?"

"We do," said Master Alderrod. "Tama, my dear, we have no choice. If Winter does not come back into the forest, life here will never be the same. These troubles with fox faeries, kelpies, red-caps— they're only the very beginning, of course. Imagine what could happen if the goblins don't hibernate."

"I agree," said Brambleburn. "A Challenge is the only way."

Alderrod looked solemn. "My friends, it is time to convene the Council."

"Excuse me, sir," Sneezle piped up, "but what do Twig and I do now?"

The First-staff blinked, as though he had forgotten the children were still there. "The best thing you can do, son, is to stay indoors when the Challenge begins. A Challenge is a very dangerous thing, requiring not only knowledge and skill but also great powers of concentration. We mustn't be distracted from our spells by looking after civilians. No, young Sneezle, don't protest. You have done your part and done it well. Look after Winter's child while we attend to Malagan."

**W**ith that, the sorcerers hurried from the room to convene the full Council, while Stin appeared, to take the children downstairs to their supper. Sneezle sighed. He understood that the sorcerers had work to do and yet he felt left out, now that their journey north had ended.

The dining hall was quiet. The magic scholars were all upstairs and even their apprentices were busy, preparing for the Challenge ahead. The children ate a gloomy meal with Stin, played silly games with Chick, then went to bed at an early hour, weary from the day's long flight. Snug within his nest of quilts by the fireplace in the big front room, Sneezle fell sound asleep, and then woke again several hours later. The library was silent. The sorcerers had all gone to bed. Try as he might, the young root faery could not get back to sleep again. He tossed, turned, tossed some more, and then gave in to wakefulness, slipping from underneath the covers and padding out of the room.

Outside on the library steps he sat and watched the distant stars, thinking about the days just past and worrying about tomorrow. What if—it was a terrible thought and probably not likely at all—but what if the royal sorcerers actually lost to Malagan?

A tall, thin shadow moved over the grass. It was Master Alderrod, wearing a long white nightgown and a stocking cap, pacing as usual.

He crossed the lawn to the young faery and looked down at him with concern. "You're thinking of Malagan, aren't you?"

Sneezle nodded, shivering.

"We may look old, young Sneezlewort, but I assure you that our powers are great. Malagan is but one wizard, and we are a full Council Circle of thirteen."

"Then," asked Sneezle eagerly, "you're quite certain you're going to win?"

Alderrod was a scholar, sworn to the truth, and so he had to admit, "No, my boy, not certain at all. Malagan was the strongest of us once, and now he's using dark powers as well. But every sorcerer has his weakness. Malagan's is vanity. What we need to do is discover how best to use it against him."

Alderrod sat down (which he rarely did) and looked closely at the boy.

"Do you know, Sneezlewort Boggs of Greenmoss Glen, that you astonish me? I have lived a long, long time and little surprises me anymore. But you! You have great power yourself, which seems to lodge in your generous heart. The forest itself looks after you and holds no secrets from your gaze. I've known great wizards who have spent their entire lives seeking the elementals . . . but instead, they show themselves to you, a humble little tree root faery."

"But we never did find Lady Winter," said Sneezle.

"Ah, but you met her sisters," said the scholar. "Spring, Summer, and Autumn all came to guide you on your quest."

Sneezle scratched his ears, puzzled. "Do you mean the maiden, the lady, and the crone?"

"Yes," Alderrod replied, "those are the shapes they took when they showed themselves to you. Heavens above, it was thrilling to see them in Mistress Tamaryst's globe!"

"I didn't know they were elementals," said the boy. "I didn't know quite *what* they were. And I never guessed that Chick might be an elemental's child."

"Neither did the greatest scholars of the realm, my boy," said Alderrod. "Even Master Brambleburn couldn't classify your little friend."

Sneezle frowned, even more confused. There were just too many riddles here. "If we met Spring as a maiden on the road, then how can Chick grow up to be Spring?"

"You met the spirit of a season that's passed," the old scholar explained to him. "Chick is the spirit of the spring to come. She'll grow up through the winter months, and soon become a maiden herself. But if Winter doesn't come, then Spring will not be able to

grow as she should. And that would be a terrible thing."

Sneezle's ears drooped around his face. These were large matters for a little faery. He sat silent, his thoughts spinning, and the sorcerer patted his knee.

"Go to bed, child. Dawn will come soon enough. And if all goes well tomorrow, the seasons will then return to their proper cycle . . . thanks to you and Mistress Twig."

Sneezle allowed Master Alderrod to lead him back inside to bed. This time the boy fell fast asleep as soon as his furry head touched the pillow, and it seemed only a moment later when Twig shook him awake.

"Wake up," she said, "it's almost dawn! They're gathering. I want to go!"

He yawned and stretched. "But, Twig, the sorcerers said we should stay here."

"They said not to distract them. So we'll hide and they'll never know we're there. It's a Challenge, Sneezle! A battle of spells. It's going to be so *interesting.*"

Sneezle looked at his friend closely. He'd never seen her so excited. Ever since she'd read that book, her thoughts had been filled with magic.

"Haven't you had enough spells yet?" asked Sneezle, pointing to her tail. Her pink mouse ears and nose had faded away, but the tail remained.

"These spells are different," Twig informed him. "These are by *professionals.* Don't you want to come with me, Sneezle?"

Actually, he did.

He looked at Chick, still fast asleep with her arms around Stin's little dog.

"Barnacus will watch her," Twig assured him. "And Stin as well."

"All right," he agreed, making up his mind, "but we mustn't let anyone see us there."

They crossed over to the tall oak door and opened it a tiny crack. The sorcerers were gathered beyond, thirteen of them, looking very grand in velvet robes and conical caps, carrying carved wooden staffs. Sneezle glimpsed Alderrod in the tallest hat . . . Brambleburn . . . Tamaryst . . . Beezwottle . . . and a small, hunched, balding wizard wearing a sword strapped around his waist. The small one was the bad-tempered guardian of the old Tree Oracle and that sword used to belong

to Sneezle. The young faery glared at him.

The thirteen wizards left the hall in a swirl of thick velvet and dust. The children waited a moment and then crept quietly behind.

They followed the scholars into the dark, dense forest behind the library, then hung back in the brambles as the others entered a woodland clearing. The clearing was marked by a circle of standing stones tall as the masters themselves—thirteen of them, like the sorcerers, deeply carved with arcane symbols. Each sorcerer stood before one of the stones, staff planted in the ground. They wasted no time, for the sun was already rising through the oak and holly.

Alderrod raised a polished rowan wand. The old man took three steps forward and cried, "Malagan, whom we call master no more, this circle summons you! Come, receive your Challenge!" He waved the wand and it began to smoke.

The air in the circle's center wavered, shimmered, and sparked with a crackling sound. A cloud of sooty mist appeared, which then turned into Malagan—seated in his tattered brocade chair and reading a book.

The man looked up from the book, startled, and then his face clouded with anger. He closed the book with a snap and rose. "How dare you interrupt me!" Malagan looked around the circle, his eyes resting on each sorcerer in turn and then on Alderrod's lined face.

Master Alderrod raised his staff. "You, sir, are summoned here to answer the charge of using dark arts to create a spell—"

"I answer to no one now!"

"—to create a spell," Alderrod continued, "that has disrupted the seasons, disturbed the faery court, and harmed the elementals."

Malagan replied, "Of course that was my spell. Who else has that level of skill?"

"You dare to admit it?" Brambleburn burst out. "You arrogant—"

"Quiet!" Alderrod cautioned him.

"Oh yes, I'll take credit for the spell," Malagan told them haughtily. "It was excellent work, thoroughly researched, and completely flawless, gentlemen." The sorcerer sat back down in his brocade chair, chin lifted proudly.

"You," Beezwottle accused, "have wreaked havoc all across this wood and the Beyond. But why?"

Malagan smiled unpleasantly. "I never cared for winter," he said. "As I recall, you never did either, Beeswax. Always complaining about the cold."

"You banished winter simply because you don't like cold?" the Master of Maps sputtered.

Malagan shrugged.

"I can think of another reason," said Alderrod, his voice raised and his eyes blazing. He did not look like a frail old man anymore, but a sorcerer of great power. "You've got a goblin army in your tower. Don't even try to deny it, sir, for we have spoken to the children you attempted to imprison there. Goblins are hibernating creatures. If snow doesn't fall, the goblins don't sleep—they stay awake to do your bidding. Stealing books, and treasures, and children."

"A few goblin guards," said Malagan, "a few strong fellows to help me with my work are hardly an army. I don't see why you should concern yourself."

"Concern?" thundered Alderrod. "You have violated Sorcerers' Law!"

"He's done more than that, you mark my words!" spoke up the small, bald sorcerer who was guardian of the Tree Oracle. "Why would he bar Winter from the forest just to keep a few work-goblins awake? I say he's got an army behind him and means to rule Goblintown!"

Malagan sighed, rolling his eyes. "Don't be absurd, you silly old man. What would I want with Goblintown? I'm merely a scholar. My aim is a noble one: to build a library. Your paltry handful of texts shall be but a footnote in elfin history, while *my* books and curiosities shall astound all the faery realm! The goblins are helping me to expand my collection. The creatures are tools, nothing more."

"And what are you giving the goblins in return?" asked Alderrod.

"This forest," Malagan said with a smirk, eyes locked on the other man's. "Now that they've got me on *their* side, they'll win the next Goblin War."

"You're planning to lead a Goblin War?" a white-robed sorceress said, appalled.

Sneezle gasped and Twig quickly slapped a hand over his mouth.

Malagan's head swung toward the sorceress, and he pinned her with his gaze. "Everything has a price, my dear. And that's my library's price."

"Enough," said Alderrod sharply. He seemed,

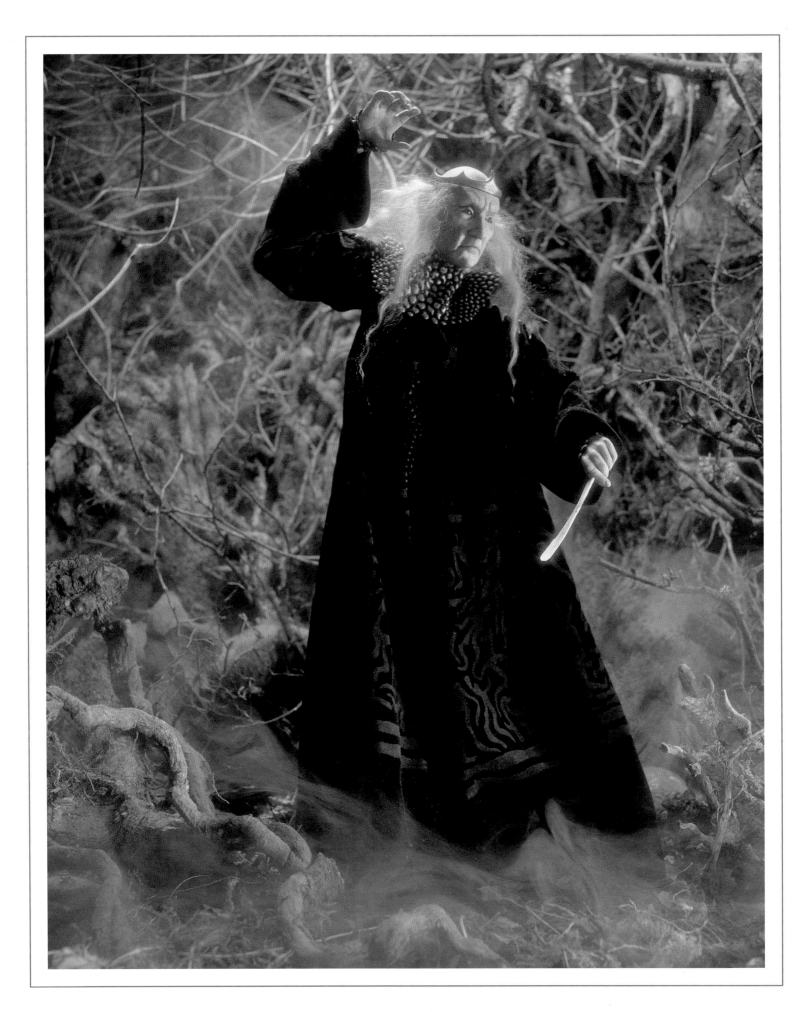

to Sneezle, to have grown even taller. "You stand accused by your own words. Disrupting elementals! Consorting with goblins! You may not take this circle seriously, but I assure you that the Council does—"

"The Council?" Malagan interrupted, amused. "Do you really think, Roddy, old sport, that I care about you doddering old idiots and your idiotic rules?"

"—and I challenge you by the Sorcerers' Book and Sorcerers' Law," continued Alderrod.

"Oh really, if you must," sighed Malagan, rising from his chair once more. He snapped his fingers and the chair disappeared. He snapped again and his staff appeared. He snapped a third time, and now there were goblins surrounding them in the forest.

Sneezle and Twig huddled further back in the shadows, away from goblin eyes—which were glued, anyway, to their master in the circle, awaiting his orders.

Alderrod kept his gaze on Malagan. "Your goblin troop can't help you. They cannot cross a sorcerers' circle."

"Ah, but there you're wrong," said the other. "Sloppy scholarship, Alderrod. No *faery* can cross this circle, it's true, but that doesn't stop these lesser creatures. Don't let them trouble you, however. I don't need goblins to fight for me. They're merely here to carry back the spoils once I have defeated you. There are books in your collection that will do quite nicely in my own."

"You haven't changed, old friend," said Tamaryst, speaking up for the first time. "You were overconfident even when you and I were first-year students together. Old Master Beadle said even then that it would be your undoing someday. That's what cost you your knee, wasn't it, back in the Goblin Wars?"

Sneezle saw a flush rise on Malagan's cheeks. Tamaryst had rattled him. He rounded on her, limping ever so slightly, leaning on his staff. "Confidence made me the best of our class! Confidence made me First-staff of the Council! And I'm quite confident that I'll defeat you now, old woman!"

The goblins growled and snuffled in the woods but did not enter the circle of stones as Malagan raised his staff with a bitter smile and called for lightning.

The lightning came at his command, clouds darkening the morning sky. It danced upon the point of his staff, then danced right through Malagan's own flesh. Sneezle, looking at Alderrod, saw the old scholar's eyes widen. Something was going on here that the First-staff had not expected.

Malagan turned slowly around, running his staff in a wide circle. Lightning flared from the tip . . . and turned the sorcerers into stone.

Sneezle gasped and clutched Twig's hand as Malagan lowered the staff to the ground, gazing with pleasure on the new ring of standing stones inside the older ring. Thirteen stones . . . no, only twelve! Mistress Tamaryst remained, her crimson robe billowing around her, oak staff in her hand.

She gave the goblin master a smile that Sneezle could not begin to read, and spoke. "I see. You're planning to limit the Challenge to you and me."

"Just you and me," the sorcerer agreed. "Just like old times, Tama."

She shook her head. "In the Goblin Wars we were on the same side, old friend."

"Then why," Malagan demanded, "did you ever tell them that I faked that paper? It was minor; it was trivial! Yet I was stripped of everything I'd earned because of some stupid rhyming spells! Jealousy, that's what it really was. I was the best the Council had ever seen! You and Roddy and all the others, you were always too frightened to use the dark powers. Not me. The Sorcerers' Law is meant for smaller talents, not minds like mine. You were supposed to join me, Tama. There would have been no rules we couldn't have broken, no spells we couldn't have made together! But instead you had to run to the others and tell them that I faked that research. *You*, of all people to betray me, after all our centuries together. I won't forget your treachery, woman, should I live to be a thousand."

"What else could I do?" she cried. "You lied to me. You lied to the Council. Sorcerers' Law binds all of us. Don't you think it broke my heart?"

He pointed at her angrily. "You didn't care what happened to me—you wanted to be First-staff, didn't you? But then old Roddy spoiled your plan and grabbed the prize himself."

Tears glittered in Tamaryst's eyes, but she stood as firm as the standing stones. "They offered me the post, my dear. Didn't you know? I turned it down."

"Impossible! You couldn't have! Why would you

have done such a foolish thing?"

"Because I saw what it had done to you," she told him softly.

He stared at her, the words knocked from him. Then the sorcerer shook his head. "I don't believe you," he said angrily. "No, I don't believe you at all! You always thought that you were better than me—well, then, here's your chance to prove it! I accept the Challenge! Will you stand for your circle, Tamaryst of the Royal Council?"

She gave him a look of iron. "I will, Malagan of Goblintown. For the future of this forest and all that live in it, yes, I will."

Sneezle stood hand in hand with Twig as the two sorcerers slowly circled each other—white haired, faces etched by age yet glowing with arcane powers.

"Fire!" the sorceress called out, binding Malagan in a ring of flames.

"Water!" he answered. Water gushed from his fingers and the fire sputtered out.

"Smoke!" A thick black cloud appeared and wrapped itself around the man.

"Wind!" he said quickly. It blew away the smoke, tore at their velvet robes, and stripped the leaves from the nearest trees before it left the clearing.

"Rock!" The earth rumbled under his feet and began to crack apart.

"Soil!" Dirt swirled, pouring into the cracks and the ground settled.

"What is she trying to do?" Sneezle whispered.

"To bind him," Twig said, eyes shining. "I read about the Sorcerers' Challenge. It's very old and famous."

"What happens if she fails?" he asked.

"Then he binds *her*. Oh, Sneezle, she mustn't fail! Just think of our beautiful forest overrun by goblins!"

He frowned. "But every word she tries he has another answer for."

"One of them will tire," Twig explained to him, "or lose their concentration. And then the other will pounce! Oh, stars above, let it be her."

"Oak," Tamaryst was calling, and a ring of trees enclosed the dark sorcerer.

"Ax," Malagan called, and an ax appeared to chop the trees down.

The goblins watched, hooting and hissing. A few placed bets on who would win, and then a dim-witted pair began to root for their master's rival.

"Birds!" she shouted. A flock of crows appeared and swirled around the other wizard. He hesitated for just a second.

"Storm!" he finally called. Rain and wind, sleet and hail drove the birds away.

"Night!" Tamaryst cried, throat hoarse.

"Light!" he said with a taunting smile. "That was much too easy, even for you. . . . Are you getting tired, *old* friend?"

"It's always the simple things you overlook," she replied. "And the little things. Like *mice*." There were suddenly dozens of them, scrambling all over her opponent.

He shook them off and shouted out, "Cats!" The cats appeared and gobbled up the mice.

Twig squeezed her friend's hand very hard. "Oh dear, oh no, something's happening. . . ." Then the thistle faery swooned. He reached for her and no one was there . . . except for a small white mouse on the ground below, peering through the brambles. Sneezle swallowed his yelp of surprise as he watched Twig scurry into the shadows. Tamaryst's spell must have renewed the old mouse spell on Twig.

Sneezle knelt down to find the mouse. She was trembling in the underbrush. "Don't worry," he whispered, "the sorcerers will fix it." But the sorcerers were turned to stone. And Tamaryst now leaned heavily on her staff, growing weary with effort.

Malagan, despite his limp, seemed barely ruffled by the power he conjured. "You see," he was taunting Tamaryst, "you cannot win against me anymore. You draw only on your own inner strength, while I use the goblins' strength as well."

It was true, Sneezle saw. Malagan looked fresh, but the goblins were panting and sweating heavily.

"I'd rather die," Tamaryst spat out, "than abuse the Sorcerers' Law that way."

"You shall have your wish, then," Malagan said softly, with a strange smile that chilled Sneezle's bones. "Or perhaps I shall make a thirteenth stone to stand here with the others. Which would you prefer, old woman—"

"Stone," said Tamaryst, breathing hard.

"An interesting choice . . ." the sorcerer began. Then he realized she hadn't answered him—she

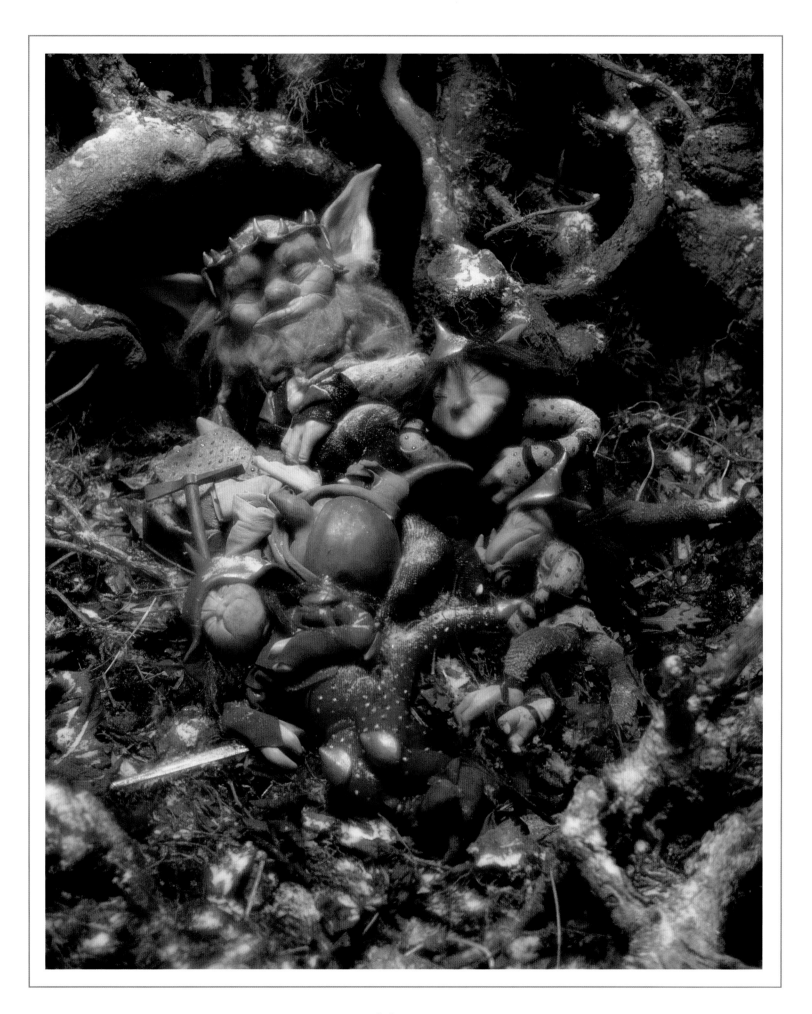

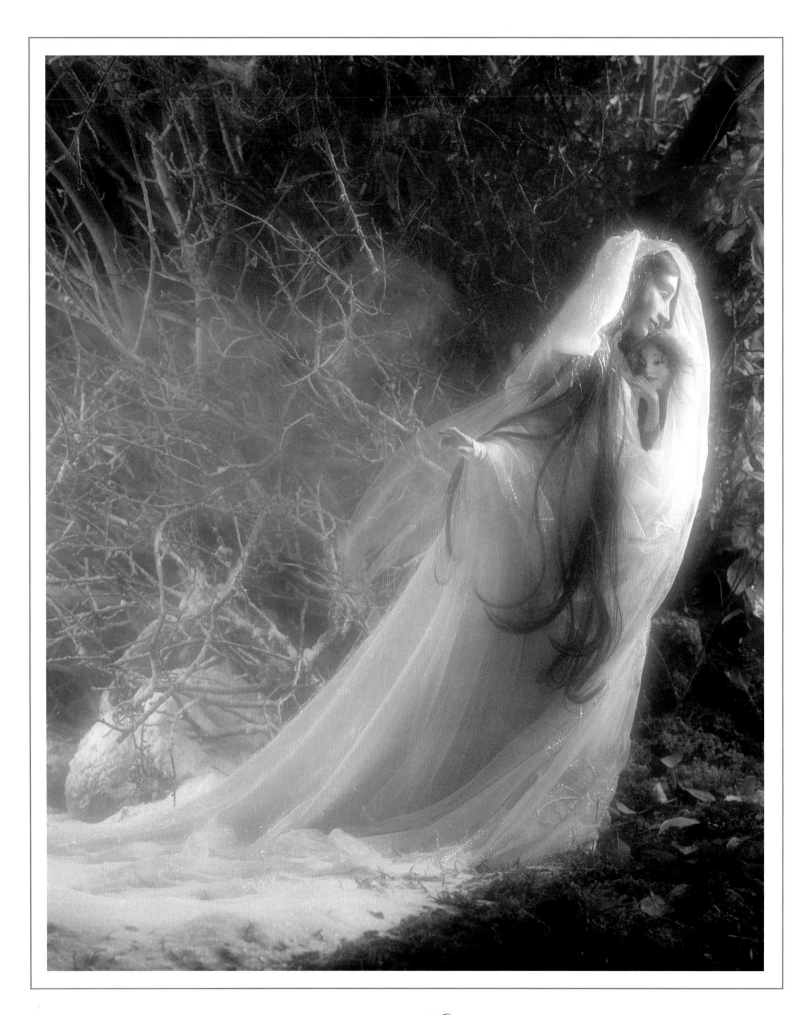

was sending him a new binding spell. His form wavered, beginning to harden. He smiled and opened his mouth to answer . . . but at that moment a mouse ran through the circle and bit him hard.

His answer turned into a shriek of pain. And as he lost his concentration, the binding spell snapped firmly shut, enclosing him in stone.

Tamaryst stumbled forward, sinking to her knees in the center of the circle next to the tall gray standing stone that Malagan had become. With his powers bound, the threads of the goblin master's own spells began to unravel. The other wizards emerged from stone, blinking in the cold sunlight, as Tamaryst knelt silently, a mouse cradled in her hands.

The goblin troop stared at the royal sorcerers and began to run.

"After them!" cried the crabby guardian, his sword raised over his head, but Alderrod grabbed him by his robe.

"Just let them go!" the First-staff said. "Let them go back home again. They're nothing without their master."

But the goblins weren't going anywhere. The air had grown very, very cold. The morning dew froze on the trees, encasing them in glittering ice, turning the entire world into a landscape carved in crystal. The air grew colder, and colder still. The sky turned gray, then white as bone. Then snow began to fall on ivy, oak, earth, stone, on goblin caps and sorcerer cloaks, as Lady Winter found her way into the faery forest.

Time seemed to stop. Birdsong faded. Silence now enclosed the wood. The goblins slowed, stumbled, yawned, lurched wearily across the lawn . . . and then fell heavily to the ground, fast asleep until the spring thaw.

Sneezle burst from the bramble patch and ran back to the library where Chick was on the steps with Stin, Barnacus at their feet. He picked her up and held her close. "Your mama's coming," he told the girl, and rubbed his cheek against her feathery hair for one last time.

He carried the child down the stairs as Winter stepped out of the trees. Her hair was the black of a starless night, her skin as white as new-fallen snow, her lips as red as holly berries, her eyes as gray as a winter storm. Ice crackled beneath her steps,

her cloak left drifts of snow behind, and two white foxes followed her with eyes like silver coins. She slowly crossed the lawn to stand before the awestruck root faery, and held her arms out silently. Sneezle placed the child in them.

"Lady Winter, we're glad you've come. We're glad you've found your child," he said—and then he added, whispering, "but, oh, we're going to miss her. . . ."

The elemental child gave a happy cry, clinging to her mother's neck. Lady Winter, bent over the girl, murmuring against her soft green hair, seemed to take no notice of the forlorn faery standing at her feet. She turned, clutching her precious one, and disappeared into the trees. Where she passed, the leaves fell gratefully, ice sheathed the bare branches, and snow soon followed after, turning the moss and ivy to white.

The old sorcerers stood on the hillside watching the Winter Child go, Twig peeking out of Mistress Tamaryst's pocket, her pink nose twitching.

"Come, Sneezle," said Brambleburn kindly, "a nice cup of tea will do us all good."

Sneezle, his heart bursting with joy and sorrow, absolutely agreed.

**D**espite Mistress Tamaryst's best efforts, it was several days before the mouse spell had faded enough for Twig and Sneezle to travel back to court. Their wooden shoe had been recovered, and now it became a perfect sled to take them to the southern woods on trails made of snow and ice. Their journey was a pleasant one, joined by other faeries on the road as they drew close to the Winterglade where the royal couple still held court.

The queen's young handmaiden had been missed, but the marsh faery was quickly forgiven when she produced King Oberon's drinking cup and the entire tale was told.

The faery king lounged on his throne and said, when the children's tale was done, "Titania, did you not promise a fine reward to whoever found my cup?"

"Indeed, my lord." Titania crooked a finger and drew the children close. "I've seen you before, my little one," she said, peering into Sneezle's face. "A young tree root faery, so easy to overlook, yet brave

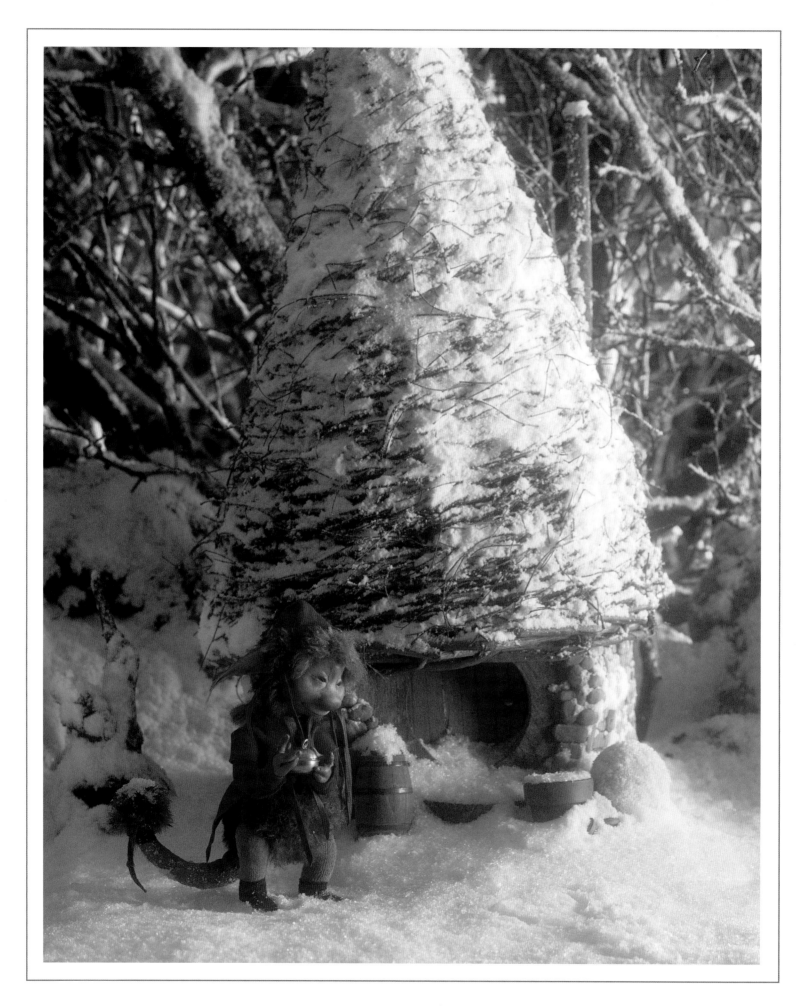

as an elfin knight. What shall I reward you with? Tell me what your heart's desire is."

Sneezle flushed and looked down at his toes.

She laughed. "Come, whisper in my ear." He did and the faery queen laughed again, tossing back her silver hair.

She clapped her hands and a golden dish appeared, covered with a golden lid. She opened it; inside, the dish was crowded with honey cakes. "This dish will never empty," she told him, "although it doesn't *always* make cakes. These magical objects have minds of their own sometimes . . . well, never mind."

Titania turned her eyes to Twig. "Now for my little handmaiden. Tell me, child, what your heart desires and you shall have it."

Twig took a deep breath. "Your Majesty . . ."

"Yes? Go on." The queen waited.

"P-please," Twig stuttered out, "please give my job to someone else."

All the court ladies turned and gasped, then whispered furiously among themselves. This slip of a girl, turning down such an honorable post. It was an outrage!

But the queen looked into Twig's clear eyes and understood. "Of course, my child. You've tried to be what others wanted you to be. You must be what you are."

"Thank you, Your Majesty," said Twig, retreating from the royal throne.

"Wait, girl. I haven't finished yet. I've promised you your heart's desire. Do you think your queen can't read what is in your heart and your destiny?"

Twig looked up at the queen, puzzled.

Titania smiled down at her. "You shall go back to the library, my dear, and study magic."

The courtiers gasped even louder this time, and even King Oberon looked surprised.

"Titania, are you quite certain? Can a marsh faery be a sorcerer's apprentice? I've never heard of such a thing! It's completely untraditional."

"There's a first time for everything," Titania said, "even in an elfin wood."

Oberon turned his gaze to Twig. "So be it, then," he said gently.

"Oh my stars and whiskers," breathed Twig, her tail twitching out from beneath her skirt.

Sneezle quickly stuffed it back again before anyone had noticed.

After the king had persuaded them to tell the story of the quest all over (particularly the part about his cup), the weary travelers were finally permitted to go home. Twig was headed for Eastern Marsh, anxious to tell her aunties her news, but she promised to visit Sneezle again on her way to the library.

Hugging his golden dish of cakes, Sneezle set off to Greenmoss Glen, glad that soon he'd reach the end of his journey at his own front door. Lady Winter had passed this way, for the moss was covered with fresh white show and the trees were bare, glittering with ice. The sky above was gray and luminescent as a pearl.

He sighed, remembering how Winter had walked away without a word. He was glad that Chick, that *Spring*, was with her mama. But still, he missed her.

Turning a bend, Sneezle saw the pointed roof of his cozy home at last. He hurried toward it—then stopped and stared. A smile spread over his furry cheeks. Winter had been here recently, too. She'd left a message, written in the snow.

*Thank you*, it said.

Underneath was a heart, drawn by a child's hand.

# Acknowledgments

Many people helped in the making of this book and have our heartfelt thanks: Toby Froud; Wendy's agents, Robert Gould and Muriel Nellis; Terri's agent, Christopher Schelling; our editor, Constance Herndon; Delia Sherman; and Olga Kaljakin. Thanks also to Guy Veryzer, William Todd Jones, Carol Amos, Peggy Midener, Ellen Kushner, Ellen Steiber, Beckie Kravetz, Alan Weisman, Jodi Encinas, Rupert Encinas, Elisabeth Roberts, and Thomas Canty for all the support you gave to this project, and to us.

*—Wendy Froud and Terri Windling*

# Dedications

To Brian, with my love and grateful thanks, always.

*—Wendy Froud*

This story was written for my favorite winter child, Garnet S-wegĭ A'an Encinas; and for her new sister, Talia Mashath Encinas, born in the spring as I finished the tale; and for Sonia Marguerite Kravetz Weisman. Sonia, bright spirit, we will never forget you.

*— Terri Windling*

# About the Artist and the Author

*Wendy Froud* became a doll maker at the age of five, and has gone on to make dolls, puppets, and sculpture for such films as *The Empire Strikes Back*—she is credited as the fabricator of its beloved character Yoda—and Jim Henson's *The Dark Crystal, Labyrinth, The Muppet Show,* and *The Muppet Movie.* Her dolls and figures are highly sought after by private collectors around the world. Froud grew up in Detroit and now resides in Devon, England, on Dartmoor, with her artist husband, Brian, and their son, Toby.

*Terri Windling,* a six-time winner of the World Fantasy Award, has been a guiding force in the development of mythic fiction and fantasy literature for more than a decade. A fairy and folklore scholar, she has written mythic fiction for adults and children (winning the Mythopoeic Award for her novel *The Wood Wife*) and published more than twenty-five anthologies. Most recently she edited *A Wolf at the Door* and *Black Heart, Ivory Bones* with Ellen Datlow. She divides her time between Devon, England, and Tucson, Arizona.

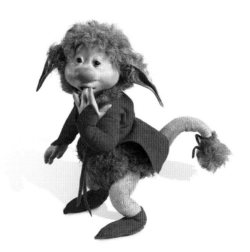

SIMON & SCHUSTER
Rockefeller Center
1230 Avenue of the Americas
New York, NY 10020

This book is a work of fiction. Names, characters, places, and incidents either are products of the author's imagination or are used fictitiously. Any resemblance to actual events or locales or persons, living or dead, is entirely coincidental.

Text copyright ©2001 by Terri Windling
Photographs copyright ©2001 by Wendy Froud
Photographs ™2001 World of Froud
A World of Froud / IMAGINOSIS Production

All rights reserved,
including the right of reproduction
in whole or in part in any form.

Visit the IMAGINOSIS website
www.imaginosis.com

SIMON & SCHUSTER and colophon
are registered trademarks of Simon & Schuster, Inc.

Designed by Olga Kaljakin, Aspect Ratio Design
Manufactured in England

1  3  5  7  9  10  8  6  4  2

Library of Congress Cataloging-in-Publication Data
Windling, Terri.
The winter child / Wendy Froud & Terri Windling.
p.   cm.
I. Froud, Wendy  II. Title
PS3573.I5175 W5      2001      813'.54—dc21      2001032777
ISBN 0-7432-0234-1

# Books from the World of Froud

*A MIDSUMMER NIGHT'S FAERIE TALE*
by Wendy Froud and Terri Windling

*GOOD FAERIES, BAD FAERIES*
by Brian Froud; edited by Terri Windling

*THE FAERIES' ORACLE*
by Brian Froud; text by Jessica Macbeth

*STRANGE STAINS
AND MYSTERIOUS SMELLS*
by Brian Froud; text by Terry Jones

Visit the Official Brian and Wendy Froud website:
www.worldoffroud.com

# Books by Terri Windling

*THE WOOD WIFE*

*THE RAVEN QUEEN*
(with Ellen Steiber)

*BLACK HEART, IVORY BONES*
(edited with Ellen Datlow)

*A WOLF AT THE DOOR*
(edited with Ellen Datlow)

Visit Terri Windling's Endicott Studio of Mythic Arts
www.endicott-studio.com